HENRY SUGIMOTO

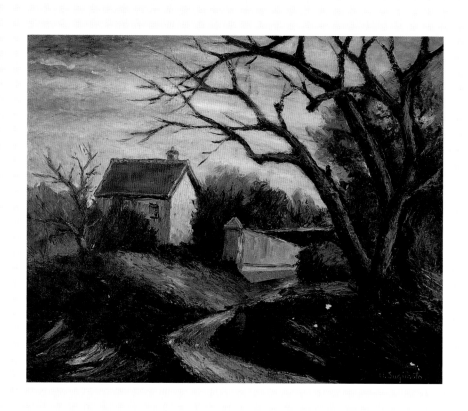

HENRY SUGIMOTO

PAINTING AN AMERICAN EXPERIENCE

Kristine Kim

Foreword by Lawrence M. Small
Introduction by Karin Higa
Epilogue by Madeleine Sugimoto
Translations by Emily Anderson

Japanese American National Museum, Los Angeles, California
Heyday Books, Berkeley, California

This publication accompanies a retrospective exhibition of artist Henry Sugimoto (1900–1990) organized by the Japanese American National Museum, on view from March 24 through September 16, 2001, in the Manabi and Sumi Hirasaki Theater Gallery, the Dr. and Mrs. Edison Miyawaki Gallery, and the Taul and Sachiko Watanabe Gallery. The project was generously supported by AT&T, the Henry Sugimoto Foundation, Winthrop Rockefeller Foundation, The James Irvine Foundation, the Los Angeles County Arts Commission, and the National Endowment for the Arts.

Front cover: Henry Sugimoto, *Self Portrait in Camp,* 1943, oil on canvas, 22 x 18 inches, (92.97.5)
Frontispiece: Henry Sugimoto, *Villiers,* 1931, oil on canvas, 21 ¼ x 26 inches (92.97.51)
Cover and Interior Design: David Bullen Design
Project Manager: Patricia Wakida
Editing: Jeannine Gendar

Library of Congress Cataloging-in-Publication Data

Kim, Kristine.

Henry Sugimoto : painting an American experience / Kristine Kim ; introduction by Karin Higa.

p. cm.

"Publication accompanies a retrospective exhibition of artist Henry Sugimoto (1900–1990) organized by the Japanese American National Museum, on view from March 24 through September 16, 2001, in the Manabi and Sumi Hirasaki Theater Gallery, the Dr. and Mrs. Edison Miyawaki Gallery, and the Taul and Sachiko Watanabe Gallery."

Includes bibliographical references.

ISBN 1-890771-38-4 (hardcover) — ISBN 1-890771-43-0 (paperback)

1. Sugimoto, Henry, 1901 — Exhibitions. I. Japanese American National Museum (Los Angeles, Calif.) II. Title.

ND237.S84 A4 2001

759.13 — dc21 00-012383

Orders, inquiries, and correspondence should be addressed to:
Heyday Books
P.O. Box 9145, Berkeley, CA, 94709
(510) 549-3564, fax (510) 549-1889
www.heydaybooks.com

Printed in Singapore by Imago

10 9 8 7 6 5 4 3 2 1

Contents

Foreword by Lawrence M. Small vii

Introduction by Karin Higa ix

Painting an American Experience by Kristine Kim

Childhood and Immigration, 1900–1924 3

Oakland and Paris, 1924–1932 11

A Rising Artist, 1932–1941 33

An Artist's Sense of Mission, 1941–1945 53

A Life Transformed, 1941–1945 83

Re-envisioning History, 1945–1990 101

Leaving Your Mark on this Earth by Henry Sugimoto 129

A Daughter's Remembrance by Madeleine Sumile Sugimoto 133

Resource List 137

Acknowledgments 139

Foreword

LAWRENCE M. SMALL

Secretary

Smithsonian Institution

IN HIS LATER YEARS, Japanese American painter Henry Sugimoto began writing his life story, stating that he was concerned about "leaving my mark on this world." As anyone who examines *Henry Sugimoto: Painting an American Experience* can see, Sugimoto need not have worried. This publication and the accompanying exhibition bring to light his remarkable artistic legacy, securing his place in history.

Sugimoto's talent was evident in landscape paintings from the 1930s such as *Cluny Museum, Yosemite River,* and *Half Dome of Yosemite.* At that time, his work was infused with multiple artistic and cultural influences, from his Japanese upbringing to the salons of Paris, as well as the magnificent California landscape. That talent, and Sugimoto's endurance, were soon to be severely tested as a result of Executive Order 9066, issued by President Franklin Roosevelt on February 19, 1942. Sugimoto, his wife, and their six-year-old daughter were incarcerated for more than three years during World War II, along with more than 110,000 other Japanese Americans who had been living in the western United States.

Initially in secret and then openly, Sugimoto created an extensive series of paintings that powerfully capture that painful time. With a clear artistic eye,

and an equally insightful view of history, he conveys the struggles, suffering, and complexity of life in a detention camp. Though the circumstances were tragic, Sugimoto found an artistic voice uniquely his own through the interpretation of that experience. One of the most poignant paintings has to be that of his wife and daughter; the title says it all—*When Can We Go Home?* This is the question that Sugimoto's daughter asked on their first day at the Fresno Assembly Center, after what she thought was a picnic lunch. As he recounted later in life, Sugimoto came to comprehend the meaning of the United States Constitution most forcefully when his civil rights were denied. Instead of faulting the American system, he used his art as a vehicle for expressing his loyalty to the ideals of this country. As a testament to his convictions, Sugimoto became a United States citizen in 1953, one year after the passage of the Walter-McCarran Act, which finally made it possible for Japanese immigrants to apply for naturalization.

The Smithsonian Institution recognized the power of Henry Sugimoto's work over a decade ago, acquiring three paintings for our permanent collection and including two of them in the National Museum of American History exhibition, *A More Perfect Union.* There they help tell a crucial part of American history, from the World War II incarceration of Japanese Americans to the Civil Liberties Act of 1988, signed by President Ronald Reagan, which authorized an official apology and reparations of $20,000 to every incarcerated Japanese American.

Henry Sugimoto's entire life story, from his immigration to his embrace of the ideals of this country, reveals an important and heretofore unknown part of our American heritage. His life and art offer us the opportunity to reexamine that heritage and, by extension, encourage us to meet the particular obligation of understanding ourselves.

Henry Sugimoto: Painting an American Experience, is a perfect example of how the Japanese American National Museum is serving the entire community with an exhibition combining history, culture, and the arts. There's no question that Henry Sugimoto left his mark on this world. It is clear, inspirational, and now, thanks to the Japanese American National Museum, it cannot be ignored.

Introduction

KARIN HIGA

Senior Curator of Art

Japanese American National Museum

IT IS A LONG WAY from the town of Wakayama in central Japan to West 146th Street in New York City's Harlem, but Henry Sugimoto traversed this wide divide in more than just the physical sense. He was born in 1900 as the grandson of a displaced samurai and died in 1990 an American painter. The paintings, sketches, prints, and drawings he made in the intervening years bear witness to a world of art and a world of politics in flux. This book and the exhibition it accompanies track Henry Sugimoto's art and life. *Henry Sugimoto: Painting an American Experience* is at once the story of an individual painter's development and an examination of an immigrant's experience. The book looks at Sugimoto's art and life during his early years in California, Paris, and Mexico; at the transformative impact of the World War II incarceration of Japanese Americans; and at Sugimoto's increasingly self-conscious attempts to express personal and community history in visual terms during the 1960s and 1970s. The book and exhibition examine how it was that Sugimoto came to paint a distinctly American experience, one that embodied a heady belief in the power of art to exist outside of individual experience and to serve as a vehicle for critique, commentary, and the documentation of stories that would otherwise remain untold.

In 1990, the Japanese American National Museum received a substantial bequest of 142 paintings from all periods of Sugimoto's career. This body of work, remarkable in both scope and subject, revealed an artist who began his career to critical acclaim as an accomplished painter of still lifes and the landscapes of California and France, but whose identity as a painter and a citizen of the world was contested by the actions that the United States government took against Japanese Americans when it entered World War II. Viewing the bequest to the museum as well as another large holding of art in Wakayama City, it became clear to the Japanese American National Museum that Sugimoto was a figure of historical significance, and we (co-curator Kristine Kim and I) began the long and careful process of research, conservation, analysis, and exhibition of selected paintings with the long-term aim of producing a major survey exhibition.

Sugimoto's legacy had been lovingly tended by his daughter, Madeleine Sugimoto, who was both a subject of and witness to her father's long career. Madeleine generously shared information and insights and welcomed Kristine and me into the home she had shared with her father. What we found there, at the end of the hall of the Sugimotos' modest though large apartment, was Henry's studio: a room filled with clear northern light, left virtually intact since his death years before. A well-used palette hung on the door of a cabinet filled with pencils, tubes of paint, sketchbooks, photographs, scrapbooks, and art. Homemade shelves extended to the ceiling, stuffed with portfolios, boxes of prints, unused supplies, and stacks of unstretched paintings, presumably removed from their stretchers to save space. In the span of a few hours, hundreds of works of art surfaced, astounding even Madeleine. Kristine and I were overwhelmed and elated as we realized that the Japanese American National Museum's collection—what we had believed to be the bulk of Sugimoto's remaining work—was just a fraction of what existed. As we pored through portfolios constructed of recycled cardboard boxes and perused Sugimoto's library of books, we stumbled upon major discoveries, minute by minute. One box held correspondence dating from the 1930s, including letters from museum directors throughout California, and Christmas cards from friends in

France. Sketchbooks from the 1930s sat neatly beside sketchbooks from the 1980s.

No sooner had we finished surveying the room than more things came out of corners and boxes. We had opened the floodgates to Sugimoto's life. Then we came upon the most startling find of all—a folder with the words "My Life Story" written on the cover. Inside were dozens of pages densely covered in Japanese. While we comprehended the magnitude of this find, it was only later, after Emily Anderson had carefully translated the material, that we fully appreciated what was there. Sugimoto's words filled out the broad contours of his biography with rich detail and a palpable sense of the man writing them. His voice, sense of humor, values, and perspectives rushed out from the pages of the story. Written when Sugimoto was seventy-eight, the life story contains facts, names, dates, and stories that betray a remarkable clarity of mind. Using the resources of the Japanese American National Museum, in particular the historical expertise of curator Eiichiro Azuma, as well as the other ephemera, photographs, and papers we found in Sugimoto's studio, we have been able to construct a rich and layered sense of the artist, his life, his communities, and his art, eloquently conveyed by Kristine Kim in the text that follows.

What became clearer as our research progressed was the tremendous divide between the periods before and after World War II. The crisis brought on by the mass incarceration of Japanese Americans had an immediate impact on Sugimoto's art. The beautiful and quiet studies of land, location, and light gave way, in subject matter and style, to a vigorous and fractured exploration of civil rights violated and the toll these violations took on his family and community. In the early days of the incarceration, Sugimoto painted clandestinely, creating powerfully simple works like *Evacuation (One Dollar for a Nice Icebox)* (page 63) that substantially differed from his pre-war work. In this painting, a disembodied hand clasping a dollar eerily emerges from the wheel of a cart, while symbols of American domesticity—a new General Electric icebox and a teal sofa—are about to be hauled away. The painting is at once a metaphoric exploration of the forced removal of Japanese Americans and a documentation of an unfortunately common occurrence whereby many people exploited the tragic

circumstances of Japanese Americans, buying their belongings for next to nothing in the days leading up to their hurried removal. Sugimoto creates a dramatic narrative here of disrupted homes and lost possibilities, using a newly found formal language to convey and comment upon his own experiences.

Sugimoto was determined to document the experiences of the war years and, as Kim describes in the text, did so in complex ways that defy easy categorization. He visualized the tumultuous feelings and dire circumstances of the incarceration in his paintings, as well as the persevering drive to survive. It is this act of using his art to simultaneously critique and affirm, to document and to interpret, to create and to disarm, that distinguishes his practice as a painter. In essence, Sugimoto began to identify as an American and an American artist at the very moment when his civil liberties and freedom of expression became compromised; the rhetoric of American ideals became real for Sugimoto only when those same ideals seemed lost. This newly crystallized identification as an American, albeit an immigrant American, is made visible as his art—subject matter and style—moves in new and provocative directions. It is this transformation that is at the core of *Henry Sugimoto: Painting an American Experience.*

Yet, this project has import beyond an analysis of Sugimoto's life and art, for the mere facts of his life provide new insight into early Japanese American immigrant communities and expand the standard conceptions of that period. While many Japanese Americans came to the United States to work as laborers, others, like Sugimoto, had different aspirations. Sugimoto joined his parents, who had immigrated before him and settled in the central California farming community of Hanford. His interest in art and subsequent matriculation at the California School of Arts and Crafts in Oakland would seem to have made him an anomaly in the Japanese immigrant communities of the 1920s. This was, after all, a decade of increasing legislative hostility towards Japanese immigrants, spurred by a highly organized anti-Japanese movement that rallied to stop immigration and limit rights of existing immigrants. Despite this unfavorable political context, Sugimoto found an open environment for the study and exhibition of his art in California, and a community of artists which

included other immigrants from Europe and Asia. In the decade before World War II, Sugimoto's paintings appeared in many settings, from a 1933 one-person exhibition at the California Palace of the Legion of Honor in San Francisco to a group exhibition of "Oriental" artists in Los Angeles in 1934. Sugimoto exhibited in mainstream venues of art, and he was part of an extensive network of exhibitions that included Japanese American painters. The catalogues, reviews, and correspondence of this period show a community of artists and audiences ranging from the San Francisco cultural elite to Japanese American communities throughout California. These various strands of Sugimoto's life suggest that a Japanese American artist could circulate freely in a number of different milieus. Sugimoto's travels to Paris and Mexico, discussed at length in the text that follows, and the Japanese artists he met along the way demonstrate the extensive international presence of Japanese immigrants in the Americas and Europe. These factors force us to reassess our understanding and perception of early Japanese American experiences; and the knowledge that Japanese immigrants and their experiences were far more diverse than is popularly recognized reinforces the tremendous loss that Sugimoto and others suffered during and after the war and their incarceration.

The relationship between ethnicity and art is another topic of discussion raised by Sugimoto's story. Is there a Japanese American aesthetic that can be read from the style or content of his art? Sugimoto was fascinated by Western oil painting. During the pre-war period, he painted the iconic California landscapes of Yosemite and the Carmel coast, as well as the French countryside and images of Mexico during his 1939 visit. He was interested in the vocabulary of painters who came before him, many of them European or European American, and by the provocative possibilities opened up by the Mexican muralists José Clemente Orozco and Diego Rivera. As a Japanese immigrant to the United States, Sugimoto was forbidden by law to become a naturalized citizen or own land; yet his second-class political status appeared to have little impact in the realm of pre-war art and culture. What is significant about Sugimoto's reception during the period before the war is that his ethnicity was just one factor among many; it appears neither to have hindered nor accelerated the

acceptance of his art. While the political rhetoric surrounding Japanese immigrants centered on the expectation that they could not become assimilated Americans, it was possible for a Japanese American artist to work outside these restricted expectations and succeed.

In the years after World War II, Sugimoto rebuilt his family life and artistic life in New York's Upper Manhattan. In paintings of this period, he returned again and again to the incarceration but expanded his visual vocabulary to create complex narratives that balance critique with a highly charged expression of emotions. A story unfolds in each painting; cumulatively, the works create a visual history where none existed. This idea of painting history became a primary focus for Sugimoto from the 1960s until his death. He created canvases that capture the early history of the Japanese American immigrant experience, from the phenomenon of the "picture bride" to Japanese American labor and the drive to be accepted and valued in the United States. Visual interpretations of this history were nonexistent in the realm of art, an absence made all the more striking by Sugimoto's powerful canvases.

Yet, the 1943 self-portrait that graces the cover of this book shows Sugimoto as he ultimately desired to be remembered: not as a political activist or documentarian, but as an artist. He stands at his easel erect, palette in hand, and surrounded by his paintings, a still life and French landscape among them. Wearing his signature beret, he looks boldly at the viewer with an arresting gaze, while the easel holds a painting marked with the signature "H. Sugimoto." In 1931, while in France, he painted a similar self-portrait (page 31). In this earlier work, he similarly dons a beret and stands before a canvas, though it is blank. His posture reveals a tentative stance further reinforced by the softness of his eyes, which appear to be searching rather than focused. The contrast between the two self-portraits highlights Sugimoto's maturation and his sharpened identity as an artist: although the later canvas was created during Sugimoto's incarceration in the concentration camp in Jerome, Arkansas, it would not be the end of his painting, but rather its beginning. Sugimoto defiantly looked out into the world and captured, in his paintings, experiences never before revealed on canvas. This is his story.

HENRY SUGIMOTO

PAINTING AN AMERICAN EXPERIENCE

CHILDHOOD AND IMMIGRATION

1900 – 1924

ON JUNE 3, 1919, Yuzuru Sugimoto stepped off the Japanese ship SS *Tenyu Maru* and embarked upon his American life. Almost sixty years later, the man who came to be known as Henry Sugimoto wrote eloquently about this new beginning in his life story. But long before he committed his memories to paper, Sugimoto began telling the story of his life in his art.

History and personal experience were not the source of Sugimoto's inspiration at the beginning of his career. In his desire to be a cosmopolitan, Western-style artist, he sought inspiration from the French countryside, Mexico City, and the landscapes of California, leaving behind many of the artistic and cultural concerns of his native country.

Throughout the 1930s, Sugimoto had a uniquely unrestricted view of the world; his passion for art and life overrode the limitations that might have been expected for a Japanese immigrant in this period. He moved easily between the Japanese American community and artistic circles in California and abroad.

In 1942, with the onset of World War II, Sugimoto's view of a world with unlimited possibilities changed drastically. Sugimoto was among the 120,000 Japanese Americans who spent the duration of the war in U.S. concentration

camps. His incarceration threw him back upon his Japanese identity, sparking a personal exploration that led him to reconsider the focus of his art and life. In this process Sugimoto found a new understanding of himself, which led to a new interpretation of his identity and the American experience in his art.

Although he was born in Wakayama, Japan, and lived there until the age of nineteen, Sugimoto was influenced by America almost from the time of his birth. Yoichi Sugimoto, his father, left for California when Henry was still a baby. When Henry was nine, his mother left Japan to join his father, who had settled in the small farming town of Hanford, about thirty miles south of Fresno in California's Central Valley. Henry and his younger brother Harry were left in the care of their maternal grandparents and other members of the extended family. Periodic letters kept Henry informed about his parents. In many ways, Sugimoto knew America initially as the land of his parents, the place that separated him from them.

Nevertheless, Sugimoto enjoyed a happy childhood in an environment that fostered his artistic talent. "I remember there being many old paintings, swords and spears, ceramics, and wall hangings in my former-samurai grandfather's house. Growing up as I did, surrounded by these old paintings and wall hangings, I liked copying them from a young age, and my grandfather would look at my copies and, sounding impressed, would say, 'Yuzuru, you drew very well. Try drawing some more.'"[1] His grandfather displayed Henry's pictures, showcasing the talent of his eldest grandson to the delight of relatives and guests. Later in life Sugimoto acknowledged the large part his grandfather had played in his choice to pursue art. He wrote: "[Grandfather's] extreme interest in my drawings, along with his praise and encouragement, gave me great strength and, in ways he could not have known, cultivated my desire as a young boy to paint and built up a strong foundation in me."

The year Sugimoto turned nineteen, his father summoned him to join the family in the United States.[2] Sugimoto left Japan for the first time, not to return until decades later, and never to see his grandparents again: "As the time came to leave my grandparents' house, as might be expected, I felt deep down a sense of reluctance to leave. My grandmother cried a lot and I, feeling

1. Sugimoto's grandfather had been a samurai until the feudal system was outlawed following the Meiji Restoration of 1868, at which time he moved to the country, built a house, and married the daughter of a wealthy family in the region. (Unless otherwise noted, all quotations in text and captions are from Henry Sugimoto's "My Life Story," an unpublished manuscript written in 1978 and translated from the original Japanese text by Emily Anderson.)

2. Among the first-generation Japanese Americans, this practice of "summoning" children and wives was not unusual. Men sometimes came to the United States first, in order to get established before sending for their wives and children.

a pain in my heart, cried also. My grandfather stayed with me [in Kobe] . . . until the day my boat left. While parting with my grandfather was difficult, I became acquainted with the many other immigrants and students aboard the ship, and we were able to have a fairly lively voyage. After an entire month, we finally reached San Francisco."

When Sugimoto later recalled his arrival in America, it was meeting his father for what seemed like the first time and reuniting with his mother after a ten-year separation that had the greatest emotional impact. After disembarking, Sugimoto was met by a man with familiar features who introduced himself, stating simply, "I am your father." That evening, father and son stayed in a hotel in San Francisco, trying to get to know one another after having spent a lifetime apart. Even as an elderly man, Sugimoto looked upon this initial meeting with regret: "Why did I not feel an incredible joy well up inside of me, now that I was meeting my real father? I regretted that my father was most likely saddened by the indifferent attitude of his own son. I deeply regret that as a result of having been a baby, not really knowing my father when he left, a great emptiness had developed inside of me." The next day they shopped for Henry's essentials, "American clothes, shoes, and hat," before traveling to Hanford, where Sugimoto's mother awaited his arrival.

Because he had been nine years old when his mother left for the United States, Sugimoto retained distinct memories of her; looking upon her again he saw "so clearly the face—engraved in [my] heart." The awkwardness of the first few days with his father dissipated with the warm and intimate reunion with his mother. Shortly after Henry's arrival, his brother Harry left Japan and joined them in Hanford. Along with Henry's two younger brothers born in the United States, the Sugimotos were together as a family for the first time.

Although he had been well educated in Japan, Sugimoto found himself unable to venture much beyond the Japanese immigrant community in Hanford because of his inability to speak English. In order to learn the language he enrolled in Hanford Union High School. In the process of learning English, he also gained a different understanding of life in America than that of his parents, who worked as farm laborers and operated a boarding house that catered

5

3. Issei is a term used to describe the immigrant generation of Japanese Americans, typically those who came from Japan to Hawai'i and the United States between 1885 and 1924. Henry Sugimoto is considered a yobi-yose, a subset of the issei generation. Born in Japan, yobiyose typically spent their formative childhood years in the United States and often had more in common with the second-generation nisei, born in America. However, the critical difference is in their places of birth. Nisei, having been born in the United States, are U.S. citizens. Yobiyose, like all issei, were classified as "aliens ineligible to citizenship" until the passage of the 1952 Immigration and Nationality Act.

to other Japanese immigrants. Interaction with the non-Japanese youth and teachers of Hanford provided Sugimoto with opportunities seldom afforded to immigrants. Despite the fact that he too was issei, Sugimoto's path was quite different from those of his contemporaries. [3]

While English and other subjects proved a challenge to Sugimoto, he excelled in art in high school and focused most of his attention on it. His teacher, impressed by his work and dedication, encouraged him to go on to art school. When he graduated from Hanford Union High School in 1924, Sugimoto moved to the San Francisco Bay Area to attend the University of California, Berkeley. After five brief years reunited with his parents and brothers, Sugimoto commenced on yet another journey.

"I spent my childhood separated from my parents and was raised and educated by my grandparents. My father immigrated to the United States, leaving my mother, my younger brother, and me behind when I was an infant and had no impression of him. When I was nine, my mother was summoned by my father and, leaving us with my grandparents, went to the United States. I was sad when my mother emigrated, but since my grandparents and my aunts and uncles were still young and lived in the same house, and since they cared for us and loved us brothers as their own children, I did not feel much sorrow or grief."

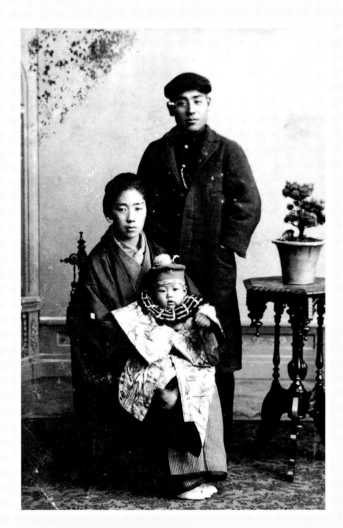

Henry Yuzuru Sugimoto (infant) with mother,
Toshi Yoshida Sugimoto, and father, Yoichi Sugimoto,
Japan, 1900.
(93.131.11)

7

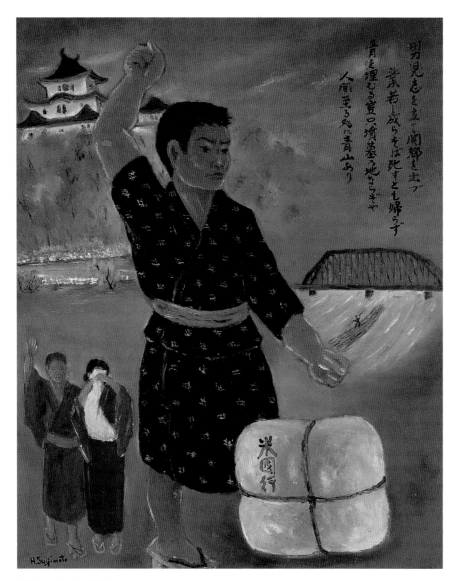

男見志を立て郷郡を出づ
業若し成らずば死すとも帰らず
骨を埋むる豊口墳墓の地を須らずや
人間到る処に青山あり

Going to America, 1980
Oil on canvas, 32 x 25¼ inches
(92.97.105)

Some sixty years after leaving Japan, Sugimoto completed a series of paintings meant to document and interpret the history of Japanese immigrants in the United States. This work, no doubt inspired by his own experience, portrays a young man leaving Japan for the United States.

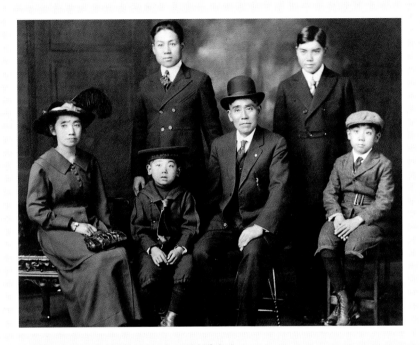

Seated from left to right: Toshi (mother), Dan, Yoichi (father),
and Ralph, with Henry (left) and Harry Sugimoto in back,
Hanford, California, ca. 1919.
(93.131.16)

"Since my mother had come to America,
I had gained two more brothers. The
year after I immigrated, the brother
who had been living with me at my
grandparents' also came to live with
my parents in Hanford. Now the entire
Sugimoto family had come to live
together."

Hanford Union High School diploma, awarded to
Henry Y. Sugimoto on June 13, 1924.
(100.2000.35)

OAKLAND AND PARIS

1 9 2 4 – 1 9 3 2

IN THE FALL OF 1924, Sugimoto enrolled as a freshman at the University of California, Berkeley. Not long after the school year began, he decided once and for all that he disliked science and abandoned his father's dream that he would pursue a career in medicine. A friend invited him to tour the nearby campus of the California School of Arts and Crafts (now known as the California College of Arts and Crafts, CCAC).[1] The introduction to CCAC inspired Sugimoto to pursue his own dream: "My desire to do art grew within me, and I dropped out of UC Berkeley and decided to go to this art school."

From 1924 to 1928, Sugimoto devoted himself to learning the fundamentals of drawing and painting. In studio classes, he learned to sketch from live models and directly from the vibrant natural landscape of the Bay Area. Sugimoto also learned watercolor and printmaking techniques at CCAC, but he focused on mastering oil painting. In addition to assigning coursework, the faculty encouraged students to visit museums and galleries, to learn from other artists.

Like many art students, Sugimoto emulated well-known artists he admired: impressionist painters like Paul Cézanne (1839–1906), and Vincent Van Gogh (1853–1890) and other post-impressionists. The radical elements of

1. The philosophy of CCAC, developed by founder Frederick H. Meyer, relied upon the principles of the European Arts and Crafts movement. Simply stated, Meyer believed that fine arts and crafts should be regarded equally, judged on the basis of aesthetic merit and technical execution.

modernism—cubism and surrealism—that were then surfacing in Europe and New York did not appeal to Sugimoto: instead, he endeavored to capture the dynamism he saw in paintings by contemporary French artists. Two artists that he named as being particularly influential were Maurice de Vlaminck (1876–1958) and André Dunoyer de Segonzac (1884–1974). Thus, Sugimoto's childhood exercises using Japanese scroll paintings as models gave way to a deeper engagement with a European style of painting.

Founded in 1907, CCAC attracted a wide range of students and teachers from all over the country and abroad. The school afforded Sugimoto lessons in drawing and painting, but more than that, it introduced a community he had not known before. Being surrounded by classmates and mentors who called themselves artists and who valued art-making had a profound impact on the way Sugimoto saw himself. He took his classes seriously and left little time for anything but school: "I became an art student obsessed with painting from morning to night. But for me, it was a great joy and gave me hope that I could become a big-time artist."

Sugimoto's first taste of success came during his third year at CCAC. An open call for artists to submit work for an exhibition caught his eye. He entered a painting of an Oakland landscape and "amazingly, this oil painting was selected for the show. . . . My teacher was surprised and congratulated me and, seeming embarrassed, told me that his painting had been rejected. As his student, I was not sure how to respond, and I very much regretted having told my teacher about my painting being selected." This uncomfortable incident did not completely overshadow Sugimoto's happiness; for the first time, he exhibited his work in a professional setting and garnered praise from fellow artists, a great encouragement that reinforced his determination to work hard.

Sugimoto received a Bachelor of Fine Arts degree in 1928, graduating with honors from CCAC. While the degree marked an important step in his career, he continued his development through additional courses at the California School of Fine Arts (now known as the San Francisco Art Institute). He also attended exhibitions regularly at two of the major art institutions in San Francisco: the California Palace of the Legion of Honor and the M. H. de Young

2. The California Palace of the Legion of Honor, made possible by the energetic philanthropy of Alma Spreckels, opened in 1921. A fine arts museum, it is known for its collection of sculpture by Auguste Rodin. The M. H. de Young Memorial Museum in San Francisco's Golden Gate Park opened in 1895. Its important collections of fine art, arms and armor, porcelain, and items from the South Pacific and Native America reflect the eclectic interests of its founder.

Memorial Museum.[2] However, the offerings at these venues did not satisfy him. When a new show opened, Sugimoto "would always go without fail, but . . . rarely had the opportunity to see the original paintings of the great European masters." Frustrated by these circumstances, he decided to go to France to study: "My greatest desire was to see those masterpieces from ancient to contemporary times. If possible, I wanted to take my time and observe these masterpieces with great care."

Sugimoto's decision to go to Europe is not surprising, given the history of artists going abroad. American artists had been flocking to Europe to develop their skills, as well as their reputations, since the late nineteenth century. In Japan, artists practicing Western-style oil painting ventured to Europe both for the artistic and cultural experiences, believing that in order to paint like a European, one must also see the world from a European perspective.[3]

The fact that Sugimoto followed a path to Europe well-trod by American and Japanese artists does not discount the bold nature of his journey. In 1978 he wrote, "When I think about it now, I break into a cold sweat and am amazed that I did such a thing without ever giving a thought as to where I was going." After cashing in a life insurance policy and his savings from odd jobs as a summer farmhand and domestic servant, not knowing anyone in France, he simply boarded a ship in San Francisco and set sail. "Feeling reassured by the fact that there were other Japanese painters in Paris and that as long as I found them, I would at least not get lost, with hardly any preparation or idea of where I would stay, I set off for Paris." Remarkably, Sugimoto's strategy worked. He later explained, "For two days I wandered around aimlessly sightseeing, hoping and praying that I would run into someone who was Japanese—I didn't care who—without any luck. On the third day, I ran into someone on the street who seemed to be Japanese, quickly introduced myself . . . and was greatly surprised—he was a painter from New York City named Fujioka Noboru.[4] When I told him I had come from San Francisco to study painting and that it was my first time in Paris, he became very nostalgic [and asked], 'Then would you like me to direct you to the hotel where I and Inoue Isao, a newspaper reporter from Watsonville, California, are staying?' These were welcome words."

3. There is a growing body of literature on the subject of Japanese modern art, in particular the work of artists during the Meiji era (1868–1912). This period coincides with Japan's modernization and the influx of Western influences in technology, economics, politics, education, culture, and the arts. Perhaps the most comprehensive English-language source on the European influence on Japanese modern art is Shuji Takashina, J. Thomas Rimer, with Gerald D. Bolas, *Paris in Japan: The Japanese Encounter with European Painting* (Tokyo and St. Louis: Japan Foundation and Washington University, 1987).

4. Japanese names are listed family name first when referred to that way by Sugimoto in his writing. In all other cases, given names are first, family names second.

13

Sugimoto quickly became friends with Fujioka and other members of the dynamic community of Japanese artists living in Paris. He relied on them for French lessons and advice on getting around the city. Fujioka and Inoue seem to have been excellent guides, taking Sugimoto to museums and arranging to visit the home of Dr. Gachet (grandson of Dr. Paul-Ferdinand Gachet, the physician and art collector who was treating Vincent Van Gogh's depression at the time of his death) in order to view works by Van Gogh. Sugimoto later recalled: "I was told by Inoue that before, anyone could freely see anything he wanted, but many . . . had come over in muddy feet . . . so not just anyone could come now. On this occasion, Inoue had waited for Gachet to grant permission, so when we went, we were immediately taken up to . . . where Van Gogh's paintings were hung and were able to see them all at once. That night, the three of us stayed in a hotel in a small farming town called Auvers,[5] and I heard that Van Gogh had been staying in one of the rooms of the same hotel when he died. In any case, I was thankful that as a result of meeting Fujioka and Inoue in Paris, I was able to have this opportunity. The next day . . . we visited the graves of Van Gogh and his brother Theodore, and returned to Paris."

Sugimoto did not have a detailed plan for living arrangements or getting around in Paris, but he clearly knew exactly what he wanted to accomplish. In addition to seeing original works of art by European artists, he intended to propel his career forward by exhibiting in the Parisian salons. Held in the spring and fall of each year, the salons showcased work by contemporary artists selected by a panel of jurors. Given the highly competitive nature of the selection process, having work included in the salons spotlighted an artist's level of accomplishment and carried with it a fair amount of prestige. Before leaving California, Sugimoto had assured friends that his work would hang in the salons of Paris.

Sugimoto enrolled at the Académie Colarossi, an art school in Paris with an international student roster of artists from Japan, the United States, and Europe and a rigorous academic curriculum that reinforced the artistic ideals of the salon. In order to fully absorb these lessons, Sugimoto needed to first improve his language skills: "I enrolled at Académie Colarossi . . . but I could

5. About eighteen miles from Paris, along the River Oise, Auvers is often called the cradle of impressionism.

14

not understand anything, because the instructor would explain everything in French; so during the day I went to the Alliance Française language school and . . . concentrated on my paintings in the afternoons and at night." Within six months Sugimoto learned a moderate amount of French and his paintings had improved. With this additional training, he stood poised for success in Paris.

In the fall of 1930, Sugimoto submitted a painting for consideration in the Salon d'Automne (Autumn Salon). Founded in 1903, the Salon d'Automne had been known since its inception for introducing innovative, non-academic art to the world, starting with impressionist painters and the Fauves and eventually becoming well-established and even fashionable. Downplaying the devastation he felt when his painting was rejected, Sugimoto noted, "I had only submitted my painting with the hope that maybe, by some chance, it would be accepted . . . I knew that it was only to be expected that it would be rejected, but it was a shock. When I left San Francisco I had boasted . . . that as proof of studying in Paris I would exhibit in the salon, but I had failed this time. When I thought about how if I didn't get accepted into the salon one of these years, I wouldn't be able to show my face to any of these friends and acquaintances, I felt quite forlorn."

Friends noticed Sugimoto's depression at what he considered to be a failure, and suggested a sketching trip to the French countryside to restore his spirits. Sugimoto and a handful of other Japanese artists went to the home of the painter Ogi, who lived in the village of Voulangis, about an hour outside of Paris. The scenery there enchanted Sugimoto: "It captivated me completely," he noted later. After a few days, the others prepared to go back to the city, but with an open invitation from Ogi, Sugimoto decided not to return to Paris.

For the remainder of his time in France, Sugimoto lived in the countryside, leaving only for short trips to visit Paris galleries and exhibitions. He found life in the country invigorating and extremely productive. The living situation enabled him to paint and sketch all day. In Ogi, Sugimoto found a companion with whom he could work; they often ventured out together to sketch and paint. "In the evening, I would hang the completed paintings on the kitchen

15

wall, and at times, Ogi would critique them." Mrs. Ogi made it possible for them both to devote themselves to their art. "When I went out to sketch in the mornings, Mrs. Ogi would even pack a lunch for me, so I could sketch the scenery wherever I wanted to until evening without having to take a break." Taking the time to focus solely on painting the appealing landscapes surrounding Voulangis gave rise to Sugimoto's first substantive body of work. As a student he had absorbed the lessons of his teachers. In the French countryside he used those skills and techniques to craft his own vision.

In the fall of 1931, Sugimoto submitted two paintings done in Voulangis to the Salon d'Automne. The news that the jury had selected one for the exhibition nearly brought him to tears. "One day I was painting and while it was still a little early . . . I decided to go home . . . Three Japanese painters, including Ogi, were out on the lawn with four or five pitchers of beer . . . Before I could even put my painting tools down, they said . . . that a notice had just arrived saying that one of my paintings was accepted. . . . I could hardly believe it and wondered if this wasn't a dream." He celebrated with his friends, but later, "when alone in my room, I said a prayer of thanks to God.[6] I had actually done this . . . I was filled with both confidence and hope as an artist." Earlier in the year he had also shown paintings in the Exposition Annuelle in the nearby town of Crècy, and in the fifth exhibition of the Union des Beaux-Arts de Lagny. While he felt encouraged by having work accepted in these exhibitions, it could not compare to the elation he felt upon being selected for the Salon d'Automne.

That Sugimoto matured a great deal within the short span of two years is demonstrated in the many paintings he completed in France, and his inclusion in the salon. He developed a solid palette that he used into the 1940s of rich brown and red earth tones sparked by lively green foliage and bright blue patches. Tiny figures appear in his paintings from this period, but it is evident that he is more concerned with forms found in the landscape—an interesting church building, windblown trees, or haystacks in a field. In France, Sugimoto concentrated on issues of color and composition, developing characteristic elements—dusky blue gray skies and winding paths that disappear into the

6. Reverend Sato, pastor of the Presbyterian church in Hanford, introduced Henry Sugimoto to Christianity in the 1920s. Sugimoto took a room in the church building where, as part of the living arrangements, he attended Sunday services. After a year, Reverend Sato baptized Sugimoto, who sustained a deep faith in God for the remainder of his life.

picture—that continue to appear in his work throughout the 1930s and 1940s, and further evolve throughout his career.

This sojourn in France, initially meant to give him the opportunity to see great art and show his work, affected Sugimoto in other, unanticipated ways. The experience broadened his view of the world and his place in it. France forever remained one of the most meaningful and inspiring places for Sugimoto, a place where he felt he had begun to mature as an artist. A short time after the 1931 salon, he returned to California, brimming with confidence and with great hopes for what lay ahead.

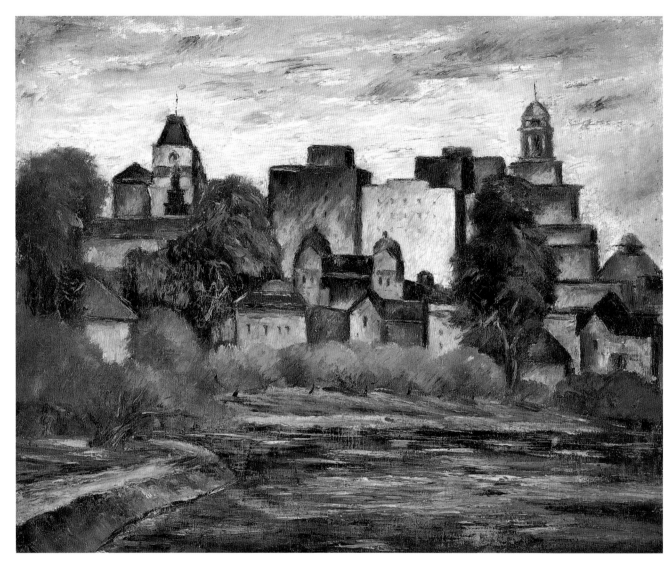

18

Oakland City Skyline from Merritt Park, 1928
Oil on canvas, 25¼ x 20½ inches
(92.97.80)

This painting was done while Sugimoto was a student at the California School of Arts and Crafts, and was possibly his first to be accepted in an art exhibition. "One of the older students praised the piece I had submitted," he wrote. "This was a great encouragement and gave me the determination to work hard."

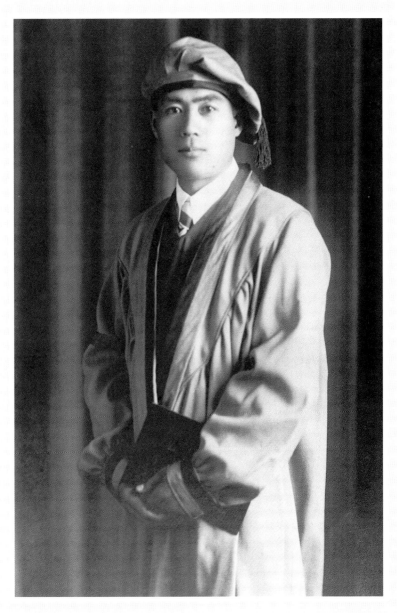

Henry Sugimoto upon graduation from the
California School of Arts and Crafts, 1928.
(93.131.24)

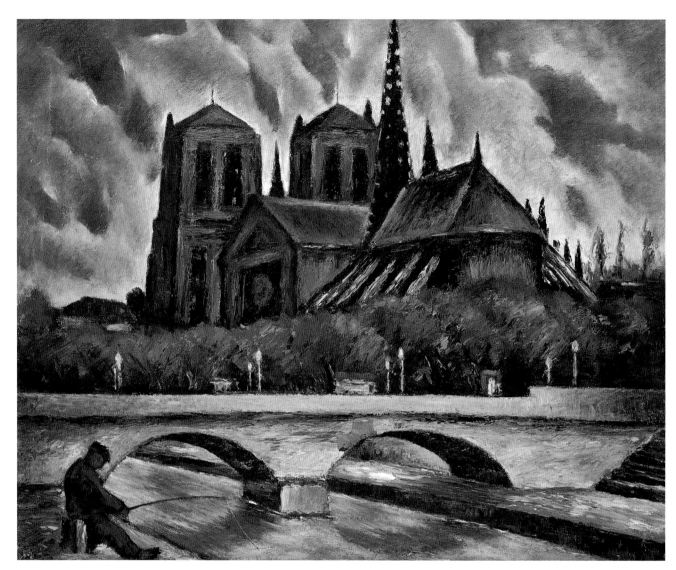

Notre Dame Cathedral, 1931
Oil on canvas, 24 x 19¹/₂ inches
(92.97.118)

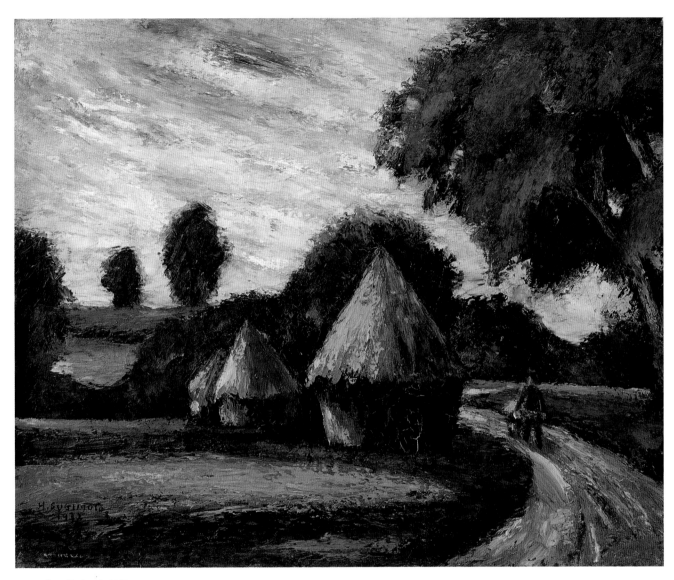

Haystacks at Voulangis, 1932
Oil on canvas, 21 x 26¾ inches
(92.97.77)

Sugimoto's infatuation with the French countryside, as well
as his admiration for the impressionist painters, led to his
prolific output of landscape paintings during this period.

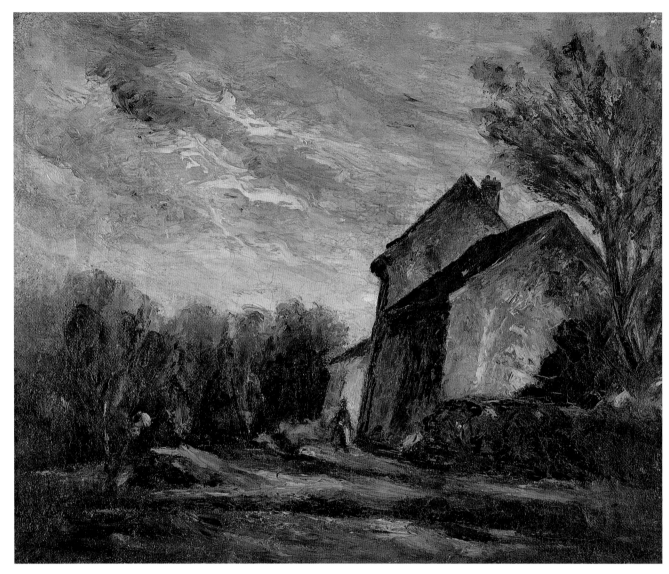

Winter at Voulangis, 1931
Oil on canvas, 14$^1\!/_2$ x 23$^3\!/_4$ inches
(92.97.128)

"I . . . would sketch the French rural landscape every day, going here and there like a man possessed. The French landscape captivated me . . . and the scenery was such that whatever you painted had the same tranquility as Millet's painting[s]."

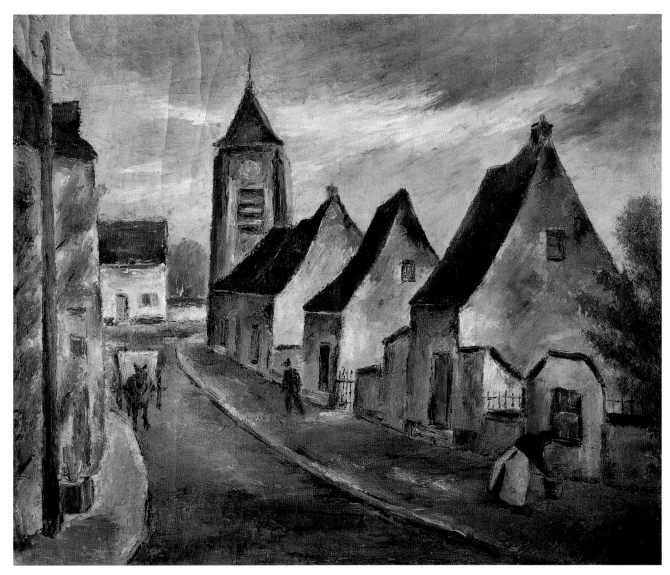

Villiers Church Street, 1931
Oil on canvas, 20¹⁄₄ x 24¹⁄₂ inches
(92.97.49)

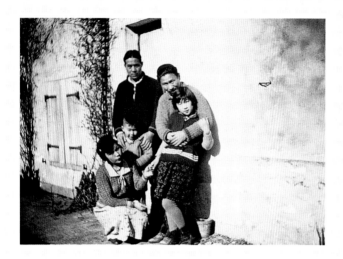

From left to right: Fujiko Ogi (kneeling), her son Tom, Henry Sugimoto, Ogi and daughter Rene in Voulangis, France, 1932. (100.2000.37C)

Photograph from Henry Sugimoto's personal collection. The handwritten inscription on the back reads: "Tom et Henry, la neige à Voulangis [Tom and Henry, the snow in Voulangis]." (100.2000.37B)

"Occasionally, Ogi would accompany me when I went out to sketch, and after the day's sketching had been completed, we would return to the house and eat with the rest of the family and relax together, and I was able to spend many enjoyable and fun days there."

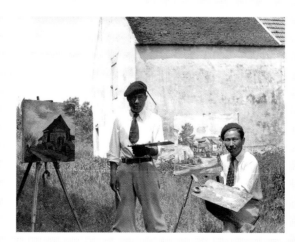

Henry Sugimoto (left) and Ogi painting in the French countryside, ca. 1931. (2000.381.4)

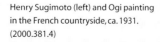

Sketches made in France, ca. 1930
Pencil and colored pencil on paper
(100.2000.5,12)

26

"In 1932, the United States was in the midst of the Great Depression, and I received word from my parents telling me to come home. Taking with me roughly two hundred paintings of the Voulangis countryside as well as the paintings I had entered in the Salon d'Automne and other shows, I returned to Hanford, California, in March. I am extremely thankful that, as a result of going to Europe out of a desire to see paintings by both ancient and contemporary masters . . . I was also able to grow a great deal as an artist."

Exhibition catalogue from the Salon d'Automne in Paris, where Sugimoto exhibited in 1931. (100.2000.19)

Untitled, 1932
Oil on canvas, 29 x 23 inches
(92.97.127)

Cluny Museum, 1931
Oil on canvas, 26 x 32 inches
(92.97.125)

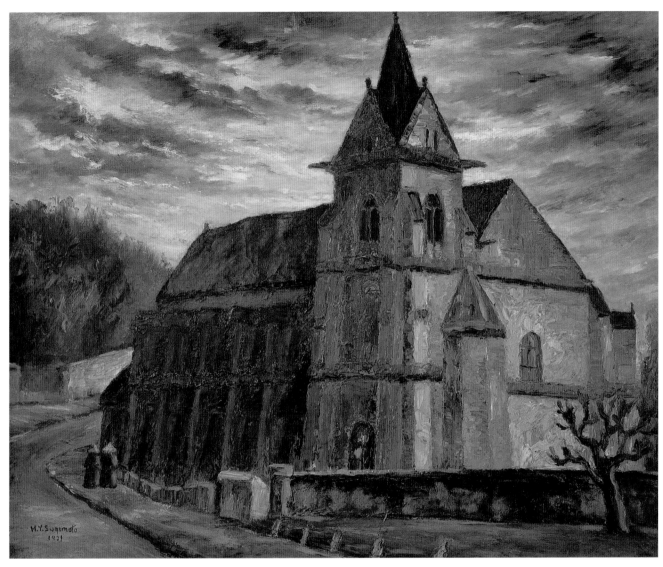

Two Nuns and Church, 1931
Oil on canvas, 26³/₄ x 32¹/₄ inches
(92.97.53)

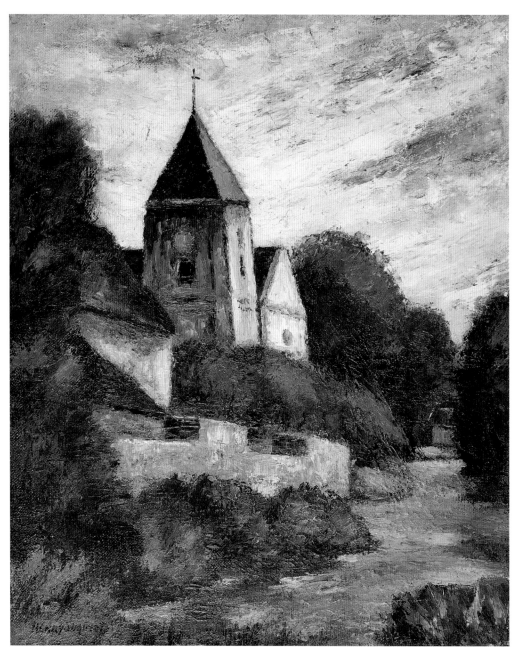

L'Eglise de Tigeaux, 1930
Oil on canvas, 26 x 21 inches
(92.97.78)

This image is the only known self-portrait painted by Henry Sugimoto during his stay in France. Sitting before a blank canvas, he wears a fashionable French beret. Sugimoto wore a beret throughout his life as a visual symbol of his identity as an artist.

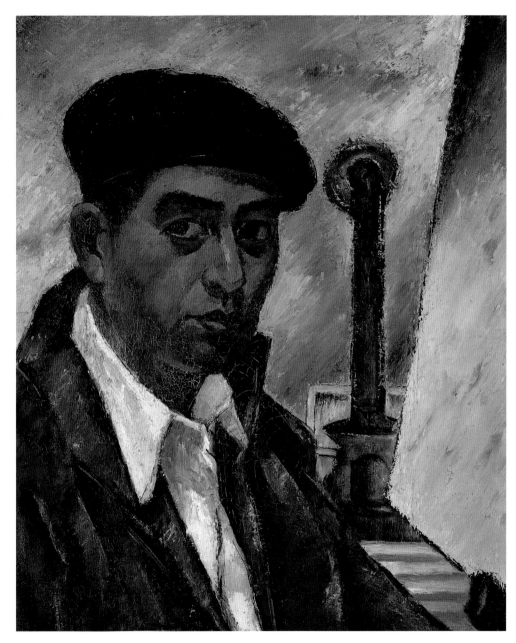

Self-Portrait, 1931
Oil on canvas, 21³/₄ x 18 inches
(92.97.106)

A RISING ARTIST

1932 – 1941

In 1932, the United States was in the midst of the Great Depression, and Sugimoto's parents let him know that they needed his help at home. He returned fresh from his success in Paris and eager to make a name for himself in California. He brought stories of adventures in Paris and the French countryside, but more importantly, he returned with an impressive body of work and experience in an international setting. The Salon d'Automne catalogue served as proof of his growth and achievements abroad. In Sugimoto's new paintings, friends and colleagues recognized major development: he was well on the way to realizing the potential his teachers had identified in him as a student.

Struck by Sugimoto's advancement, his former anatomy instructor introduced him to Dr. Walter Heil, director of the California Palace of the Legion of Honor. Impressed by the work, Dr. Heil immediately decided to hang the same painting that had been exhibited in the Salon d'Automne, *Far View of Villiers,* at the Legion of Honor. This was just the beginning, though—Dr. Heil wanted to introduce the rising artist to San Francisco and offered Sugimoto his first one-person exhibition.

This opportunity promised Sugimoto exactly the exposure he needed, and he spent the next several months preparing for the exhibition. As a student, he

had worked as a "schoolboy" for the Hoyt family, and in order to support himself, he returned to his former job.[1] During the day, he took care of the Hoyt household, leaving evenings free to work on his paintings. "Without any help from anyone, with only meager resources, I was able to do a one-man show. . . . The paintings I had done in Paris were framed and, looking splendid, were hung in two rooms of the museum."

On June 2, 1933, the California Palace of the Legion of Honor opened the *Exhibition of Paintings by Henry Sugimoto.*[2] The accompanying brochure announced, "A rising artist, whose achievements are the results of unceasing endeavor, strong will power, and perseverance, is Henry Sugimoto." The editors of the *San Francisco Chronicle* enticed readers with the colorful headline, "Legion Palace Exhibits Work of Talented Son of Samurai."[3] A photograph of one of the paintings, *Village of Villiers,* ran on the front page of the Art and Music section of the *Chronicle's* Sunday edition, displaying the completely Western style of Sugimoto's art. Explaining this presumed incongruity, the accompanying article noted, "How in art, inheritance may be wed to a new environment, is discovered in Sugimoto's first American exhibition . . . Enjoyment of the beauty of placid fields and wind-modeled trees is bespoken by Sugimoto's French rural landscapes . . . His landscapes are not in the least Japanese in style, but neither do they betray an overeager absorption of the modern trends that fascinate Europe and America today. Love of nature is inherent in the Japanese; their fingers seem especially sympathetic in the transference of nature's harmonies and delicate forms to paper or canvas."

From all points of view, the exhibition was a success. The recognition he received gratified Sugimoto and vaulted his career to an unanticipated level. He later wrote, "The response to the exhibit was surprisingly good . . . and I was extremely pleased. At the end of June, Dr. Heil said that they would extend the show into July. Of course, this came as a result of all of the praise, and while I was only able to sell two or three paintings, it is certain that I, a no-name Japanese painter, was being acknowledged as a professional artist, not only in San Francisco, but nationally as well."

The exhibition attracted the attention of dealers, curators, and museums

1. The term schoolboy, along with houseboy, is used in reference to Japanese immigrant men who performed domestic duties for American families in exchange for room, board, and nominal wages. Many student laborers took these jobs in order to accommodate their school schedules.

2. Sugimoto displayed thirty-three paintings in total, most of which are believed to have been painted in France. The exhibition was originally scheduled to run from June 2 through July 4, 1933, but was extended through the summer.
3. *San Francisco Chronicle,* Sunday, June 4, 1933, sec. D3.

throughout California and New York. Courvoisier Gallery in San Francisco contacted Sugimoto at the close of the Legion of Honor exhibition and offered to represent him. Eager to make a living as an artist, he agreed: "The paintings hardly sold at all, but I was no doubt happy that while still an art student, I had become important enough as an artist that a major gallery was handling all of my work."[4]

With little guidance from anyone and no experience whatsoever in the business of art, Sugimoto's responses to exhibition requests were as naive as they were pragmatic. When the Museum of Modern Art in New York offered to exhibit his paintings, he declined, apparently because he had already committed to showing in a number of California locations.[5] Years later, he regretted the missed opportunity, acknowledging that his lack of familiarity with the American art world had led to an unfortunate decision. At the time, he "hadn't even had any contact with the art communities in New York City" and did not comprehend the magnitude of the offer.

A regrettable incident, this story nonetheless reveals the high regard that Sugimoto's work found in mainstream institutions during the 1930s. It also demonstrates Sugimoto's straightforward and ingenuous attitude towards the art world. Unprepared to deal with the business of making art, he trusted those who contacted him, and he agreed to opportunities as they arose. He simply wanted people to see and appreciate his art.

Although Sugimoto did not capitalize on the offer to show his work in New York, his paintings were being shown throughout California. The Oakland Art Gallery, the San Francisco Museum of Art, and the Foundation of Western Art began showing his work regularly in group exhibitions.[6] The City of San Diego wrote in March 1935, requesting work for the California Pacific International Exposition, for an invitational exhibition that would emphasize California artists. "We are considering exhibiting your *Peasant's Utopia* from the recent Western Foundation Association [show] in Los Angeles," the director wrote, "and are wondering if you will be good enough to hold this picture for us until we give you more definite information."[7] In the summer of 1939, the San Francisco Museum of Art wrote to Sugimoto about his painting *Mountain Stream,*

4. After World War II, Sugimoto discovered that the gallery had closed while he was incarcerated in Jerome, Arkansas. Approximately one hundred paintings by Sugimoto that had been in the gallery's possession when Pearl Harbor was bombed were auctioned, and Sugimoto was never able to recover them.

5. Sugimoto recounted this incident in his autobiography.

6. The Foundation of Western Art in Los Angeles was an important venue for art exhibitions during this period, as was the Oakland Art Gallery, which later became the art department of the Oakland Museum of California. For Sugimoto, one exhibition led to another. As early as the fall of 1933, the California Palace of the Legion of Honor hoped to organize another exhibition featuring Sugimoto, along with three other Japanese American artists, Masuta Narahara, Kenjiro Nomura, and Kamekichi Tokita. (From Sugimoto to Dr. Walter Heil, 21 November 1933, Henry Sugimoto papers, Japanese American National Museum.) Later that year, the Oakland Art Gallery included Sugimoto in its annual exhibition.

7. Director Reginald Poland, Fine Arts Gallery, City of San Diego, to Henry Sugimoto, 8 March 1935, Henry Sugimoto papers, Japanese American National Museum.

35

which had been shown in California, Washington, and Indiana in their traveling exhibition: "Everywhere it has received favorable comment."[8]

In 1938, E. C. Maxwell, director of the Foundation of Western Art, wrote to Sugimoto inviting him to send work for their first annual *Review of California Art,* "the first time that any western museum has attempted to bring together an annual showing of prize-winning paintings by California artists."[9] Typical of the many invitations Sugimoto received in the 1930s, this letter indicates the strong association between his work and California art in general. Exhibition organizers sought him out to represent California at a time when West Coast art institutions were struggling to overcome the notion that they were less significant than those of New York. A variety of circumstances had helped Sugimoto establish himself as a California artist. Not only did he hail from the Central Valley, he had attended two of the most notable art schools on the West Coast, the California School of Arts and Crafts and the California School of Fine Arts. Throughout the 1930s he further linked himself to trends in California art by depicting the landscapes of the West.

Although Sugimoto concentrated on exhibiting and painting throughout this period, his art did not completely consume his life. In 1934 he married his longtime sweetheart, Susie Tagawa. As a high-school student in Hanford, Sugimoto had known the Tagawas, one of many Japanese American families in the area. Mr. and Mrs. Tagawa had immigrated to the United States around the turn of the century and settled in Hanford around 1906, where they established a hand-laundry business. In 1910 they had their first daughter, Susie, and ten years later another daughter, Naomi. At first, Susie had regarded Henry Sugimoto as an older brother, since he was among the oldest of their generation in Hanford, but when she neared graduation from high school, they began a serious courtship.

As much as Sugimoto dedicated his life to art, he equally devoted himself to Susie. The two became engaged before his departure for France. During their separation, friends advised Susie that despite his promises, Sugimoto would never return to Hanford. He proved them wrong and married Susie at the Japanese Presbyterian church on April 24, 1934.

36

8. Marguerite Hickey to Henry Sugimoto, 1 June 1939, Henry Sugimoto papers, Japanese American National Museum.

9. E. C. Maxwell to Henry Sugimoto, 15 April, 1938, Henry Sugimoto papers, Japanese American National Museum.

After the wedding, Henry and Susie moved to the Bay Area, where they lived for about two years. When Susie became pregnant they decided to go back to Hanford to be near their families. Susie, Henry, and daughter Madeleine lived with the Tagawas, taking up residence in a room on the second floor of the laundry building. To support his family, Sugimoto worked in the laundry and also took a part-time job teaching Japanese-language classes at the local school for nisei children. All the while, Sugimoto circulated his work and continued to paint.

Travel within California and to Mexico provided a necessary reprieve from the daily struggles of making a living and offered time to focus on painting. Sugimoto made several extended trips to Yosemite Valley in the mid-thirties, sketching and painting directly from nature. The colossal scale of Yosemite Valley, including the mountains and bluffs, posed a new challenge: a small canvas suited the intimacy of the French countryside, but Yosemite required a different approach—in scale and in feeling. "I would always prepare a [36 x 25 inch] or [46 x 31 inch] canvas," he wrote. "It is very difficult to paint the cliffs and mountains on a small canvas, and I knew from my many trips to Yosemite that the rock formations were enormous . . . If one is to try to capture this scenery, even a [46 x 31 inch] canvas seems too small."

Sugimoto also traveled to Carmel, where he was surprised to find that the scenery, "the white sand on the beach, the green cypress trees blowing and bending in the wind," reminded him of Japan. As he had in Yosemite, Sugimoto ventured alone on this trip: "I drove along the beach looking for a place to stop. I finally found a place that would serve as my home for a couple of weeks, so I . . . pitched my tent . . . then walked around to look for a good place to sketch. . . . The scenery of this coast is particularly beautiful. I could hear waves break, sometimes close by, sometimes in the distance; it was a lively place. There weren't many people, and it was more peaceful than I had expected. A cool ocean breeze was blowing and would caress my face as it went by. The air was clean, and up above, there wasn't a cloud in the cobalt blue sky."

In addition to traveling throughout California, including Los Angeles and San Diego, Sugimoto took an extended trip to Mexico. The 1939 trip offered

37

a chance to visit another country and to experience firsthand the work of the Mexican muralists. A friend with business ties in Mexico helped Sugimoto with his travel arrangements. He first stopped in El Paso, Texas, where a Japanese American doctor assisted him with the necessary passport paperwork. Sugimoto later described walking across the border between the two countries: "There is a river that runs between the United States and Mexico, and the bridge that hangs over it is divided down the middle. Dr. Furugoochi and I walked to the center of the bridge so that we could go to the Mexican immigration office on the Mexico side, but I had been absent-minded and forgot to bring my passport. When I tried to return . . . I could not pass through the U.S. border checkpoint. It wasn't until I explained that I was a longtime resident of the United States . . . educated there . . . currently making my living in the United States as a painter and on my way to Mexico on a sketching trip, that we were able to reenter the U.S. side. I was made very aware by the experience just how dependent I was on my passport."

From El Paso, Sugimoto took a train to Mexico City, where he met several Japanese businessmen who lived and worked there. Through these contacts he found an affordable place to stay and learned to get around the city. Although these acquaintances offered to take Sugimoto sightseeing, he declined in order to spend time on his art. "Mr. Iijima was going to show me around . . . but after seeing the city for a few days, I told him that as a painter I wanted to spend my time sketching at my leisure, so I ended up wandering around town. . . . Sometimes Mr. Nagabuchi would leave town to go golfing and I would ride in his car with him for part of the way and would be dropped off so I could sketch." With his limited Spanish, Sugimoto ventured in and around Mexico City, sketching as much as possible: "One day, I took the bus to the town of Taxco, and I sketched the winding town streets and an old cathedral. While I was sketching there, a young man who appeared to be a Mexican artist offered me a chair and told me to sit there and draw, and I was deeply moved. My heart was touched by his kind actions towards . . . a Japanese man [who] was of a different nationality than he was."

His business contacts enabled Sugimoto to have a small exhibition in the

Mitsui company offices in Mexico City, where he hung about ten paintings, all done while in Mexico. Many of the employees purchased paintings, provoking in Sugimoto thoughts about settling in the city for several more months.

The unexpected opportunity to show and sell paintings pleased Sugimoto greatly, but overall his experience in Mexico transcended the realm of business accomplishments. Mexico City inspired him to incorporate city architecture and ordinary people into his work. Public murals by Mexican artist José Clemente Orozco exposed him to painting done on a monumental scale with the purpose of telling a narrative through paint, a style of painting that later proved to be useful for Sugimoto. During this period, the human figure depicted in elemental, almost abstract form appears for the first time as a dominant subject in Sugimoto's work.

Sugimoto spent about a month in Mexico before illness necessitated an early departure. Forty years later, at the age of 78, he still longed to return, noting, "I am still waiting for another opportunity to go to Mexico City . . . but it doesn't seem like I'll be able to go for quite some time."

The 1930s had been a promising period, and the future looked bright as Sugimoto entered his forties. From the moment he had returned from France, he had met with success, and interest in his work continued to grow. He had begun to sell paintings and earn recognition through exhibitions. Susie and Madeleine provided stability in his life and a new font of support. The impending U.S. entry into war with Germany, Italy, and Japan raised only moderate concerns for him and his family. Sugimoto could not anticipate the profound effect it would have on his life and art.

39

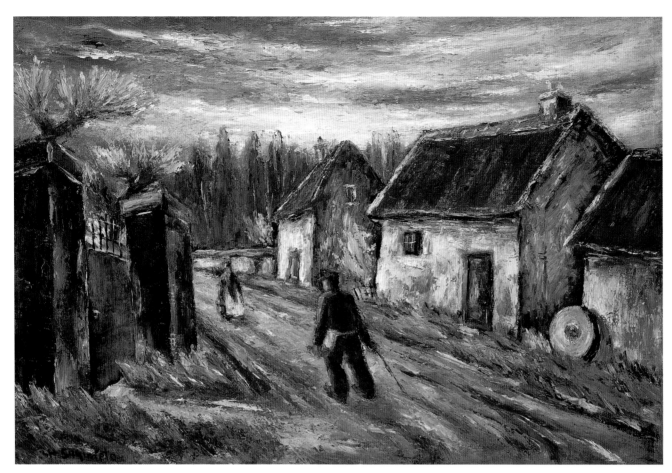

Village of Villiers, 1930
Oil on canvas, 16³/₄ x 23¹/₂ inches
(92.97.76)

Village of Villiers and *French Willow Tree* were among some two hundred paintings that Sugimoto brought back from France. It was a solid body of work, and he was invited to do a one-person exhibition at the California Palace of the Legion of Honor in San Francisco soon after his return.

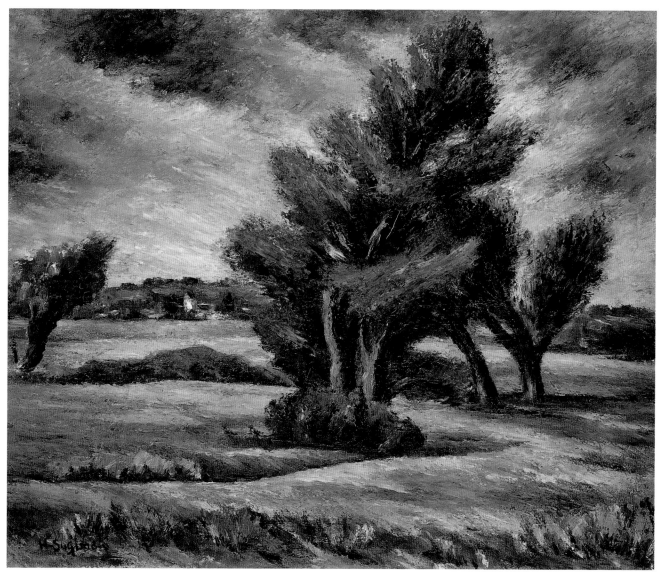

French Willow Tree, 1932
Oil on canvas, 18 x 21¾ inches
(92.97.87)

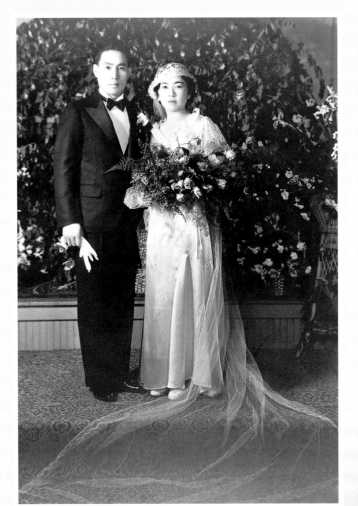

On April 24, 1934, Henry Yuzuru Sugimoto and Susie Sujiko Tagawa married at the Hanford Japanese Presbyterian church. The local press announced the nuptials with the article "Painter Weds Hanford Girl," naming the entire bridal party and noting, "The church was elaborately decorated, and a big crowd witnessed the ceremony.... After the ceremony a reception was held at the Hanford gakuen hall [Japanese community center], where more than one hundred American and Japanese friends attended."

42

Photograph of King's Laundry, circa 1910, established and operated by the Tagawa family beginning around the turn of the century and still in business today. The original building stands as a historic landmark and continues to house the hand laundry now run by the Tagawas' youngest daughter, Naomi.

Sugimoto was intrigued by the white sandy beaches and cypress trees of the Carmel coast, which reminded him of Japan.

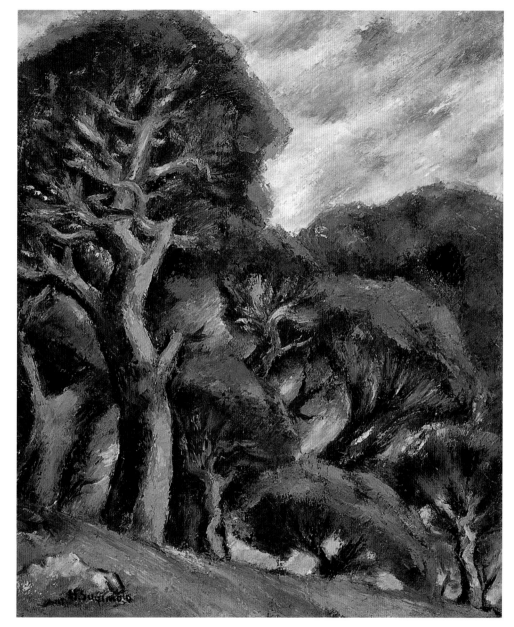

43

Cypress Trees, 1940
Oil on canvas, 19½ x 24 inches
Collection of Madeleine Sugimoto
(NY 299, FAE 163)

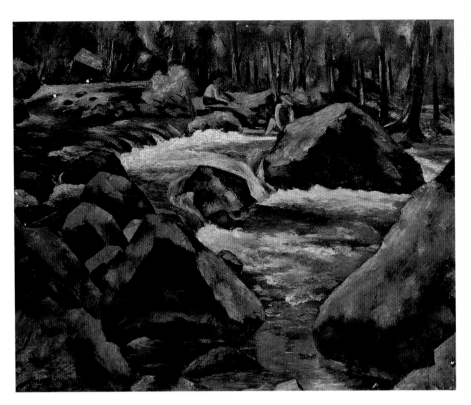

Yosemite River, 1935
Oil on canvas, 31¼ x 39 inches
(92.97.135)

Sugimoto's palette and approach
to these paintings are similar to
his work in France, but here he
is working to recreate the more
dramatic landscapes of California.

"I would paint at the base
of mountains, or I would paint
mountains from a distance, and
at times I would choose a place
rarely visited by others and set up
my easel and, in the stillness there,
paint to my heart's content."

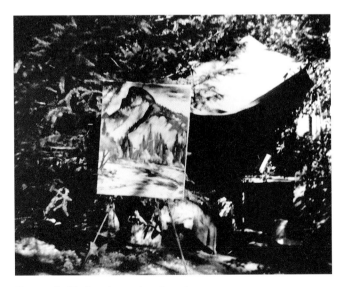

Photograph of Sugimoto's campsite at Yosemite
with one of his paintings of Half Dome, 1935.
(2000.381.23)

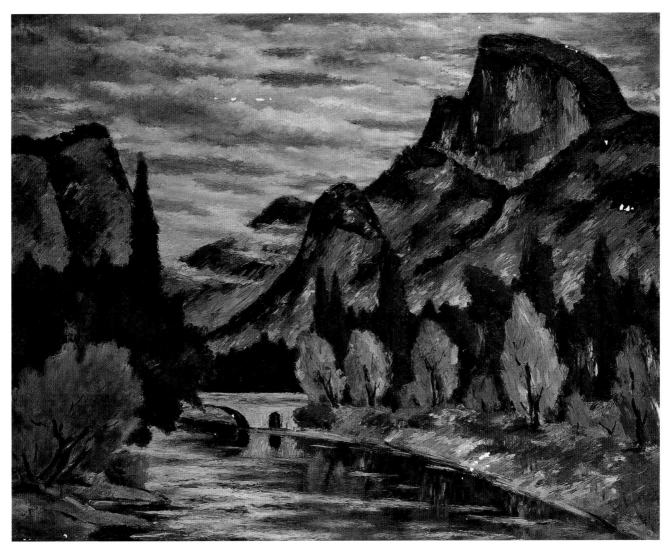

Half Dome of Yosemite, 1935
Oil on canvas, 27 1/2 x 35 1/2 inches
(92.97.134)

This painting is similar to the image in the photograph on the facing page. Given Sugimoto's concern with capturing the monumentality of Yosemite, it is likely that he initially painted the smaller versions on site and then, after returning to Hanford, used the original works as the basis for the larger canvases.

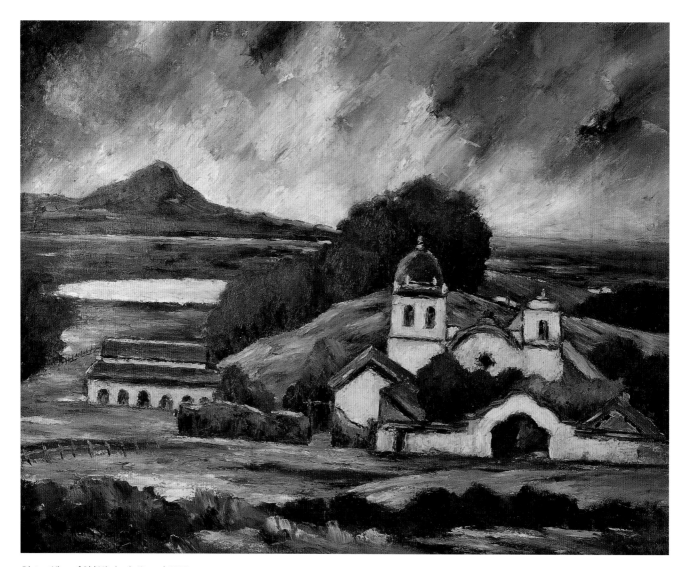

46

Distant View of Old Mission in Carmel, 1939
Oil on canvas, 26 3/4 x 32 1/2 inches
(92.97.52)

The Old Melody, ca. 1937
Oil on canvas, 25 x 32 inches
Collection of Madeleine Sugimoto
(NY 176, FAE 82)

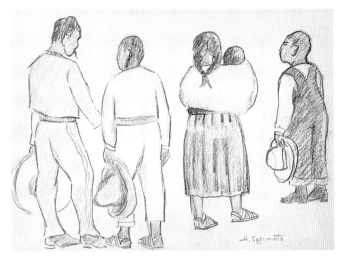

Sketches made in Mexico, 1939
Pencil and colored pencil on paper
(100.2000.6)

Sugimoto's sole purpose in Mexico was to sketch and paint. While interested in seeing the country, he intended to do so as an artist, not a tourist. The friends and contacts he made in Mexico at first offered to host him as they would any other visitor but soon realized that Sugimoto preferred to explore on his own, painting and sketching.

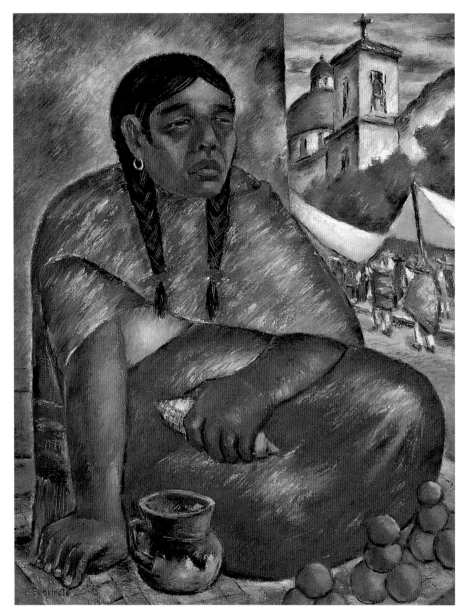

Mexican Woman in Marketplace, 1939
Oil on canvas, 32 x 25 inches
Collection of Madeleine Sugimoto
(NY176, FAE86)

It was in Mexico that figures first began to dominate some of Sugimoto's paintings. The influence of Diego Rivera, José Clemente Orozco, and other Mexican muralists is evident here, in the subject— an ordinary person—as well as the monumental aspect of the figure.

"Since I had visited all of the noteworthy museums in town, been able to complete many sketches, and seen the mural by José Clemente Orozco, I had no real regrets upon leaving. I bid farewell to Mexico City, intending to return at some point."

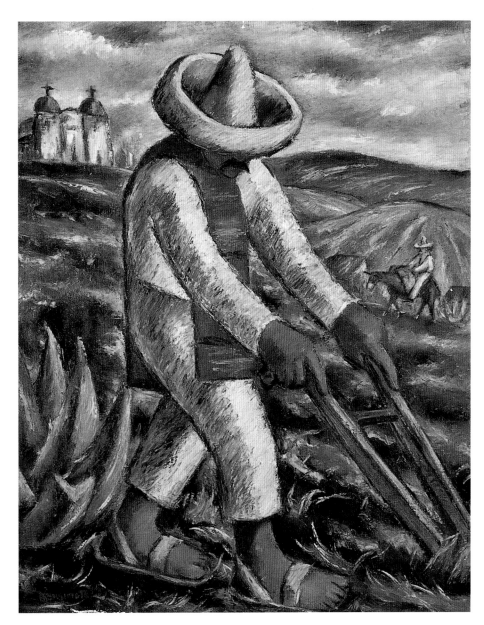

Mexican Farmer, 1939
Oil on canvas, 32 x 25½ inches
Collection of Madeleine Sugimoto
(NY184, FAE87)

AN ARTIST'S
SENSE OF MISSION

1 9 4 1 – 1 9 4 5

THE BOMBING OF Pearl Harbor by the Japanese military on December 7, 1941, set in motion a series of events that forever transformed the lives of Japanese Americans. While he could not predict his future incarceration, Henry Sugimoto understood immediately that there would be grave consequences for him and his family. Within forty-eight hours of the bombing, the FBI arrested over twelve hundred issei men in Hawai'i and the United States. The swift nature of the arrests indicates that the U.S. government had already identified these individuals and had been monitoring their activities. Many of them taught at Japanese-language schools and martial-arts organizations, while others were Buddhist priests or members of the Japanese-language press, all occupations perceived by the U.S. government to indicate strong ties to Japan and security risks.

Suddenly, the Sugimotos found themselves caught up in the wave of fear that was spreading throughout Japanese American communities along the West Coast. "The Japanese-language newspaper," Henry Sugimoto later wrote, "reported daily that Japanese who lived all over were being taken by the FBI. According to the newspaper, Japanese-language schoolteachers were being taken, from Los Angeles all the way up the West Coast to San Francisco. Had I

been only an artist, I would have had nothing to worry about, but the fact that I had taught even a little Japanese came back to haunt me, and the Buddhist-church Japanese schoolteacher and I increasingly found ourselves in danger."

FBI arrests occurred even within the small Japanese American community in Hanford. The arrest of the bookkeeper at the Hanford Japanese-language school truly alarmed Sugimoto and the rest of the community. "I started to think that this same fate awaited me in the near future, and I was tormented daily by quite unpleasant thoughts. I wouldn't have worried too much if my wife and child were going to be taken along with me. I didn't think I could bear being separated from my family." While newspapers reported the FBI's activities, no one could say for certain what happened to those arrested: "After a while, rumors spread that [they] were taken out to the desert and all shot by a firing squad, and other rumors conjured up equally astonishing images. We heard that someone who had pictures of the emperor and empress [of Japan] had been arrested [as well as those] having binoculars or a gun." Sugimoto had a telescope and pistol that had been his father's, which caused tremendous worry until he finally buried them in the backyard.

Once these items were disposed of, Sugimoto's involvement with the Japanese-language school presented the most distressing and urgent problem. The FBI had arrested both the director and the bookkeeper, and a friend reported that Sugimoto's name was seen on a blacklist. As the only person not arrested, Sugimoto held responsibility for the school: "The thing I was most worried about was the Japanese books on the shelves. [I thought] if these books were to catch the FBI's eye, I would be arrested, so I discussed what to do about them with several parents from the school, but everyone was so afraid, no one would help me. During the first few days I sneaked into the school in the middle of the night and, taking as many books as I could carry, went to the small house behind ours to burn them in the stove." This proved to take much too long, so with a car full of books, Sugimoto drove out to a field, poured fuel onto the books, and attempted to burn them. "But only the parts soaked in fuel would burn. In the end I buried all of the books. After many days I finally finished and was able to relax somewhat. I finally felt like trying

to paint again, so I set up my canvas. But even when I faced the canvas, I was so nervous that I just couldn't seem to lift my brush. From time to time, my wife would say that just now two people who looked like the FBI were coming this way, and my heart would start pounding, and I would glance towards the window. When, after a while, no one would show up . . . I would feel relieved momentarily, but I would continue to feel ill at ease."

In retrospect, Sugimoto's actions seem to border on paranoia, but nearly everyone in the Japanese American community shared his apprehension to varying degrees in the period following the bombing of Pearl Harbor. By early spring the widespread fear of FBI arrest dissipated, replaced instead with the chaos and upheaval brought on by Executive Order 9066. In February 1942, President Roosevelt signed the order, and by early March the War Department had begun the mass removal and incarceration of over 110,000 Japanese Americans living on the West Coast.[1] Among the official reasons the government gave for the incarceration was the contention that Japanese Americans, two-thirds of whom were American-born citizens, posed a threat to national security. In fact, not a single Japanese American was ever found guilty of espionage. The government, in essence, unconstitutionally denied civil rights to its citizens on the basis of race. First referred to as concentration camps by the U.S. government and then later by the euphemisms "assembly centers" and "relocation centers," the camps where Japanese Americans were interned represent the culmination of a history of anti-Asian sentiment and legislation.[2]

The evacuation orders allowed only days for people to prepare, and they had no real knowledge of where they would end up, or if they would ever return. Sugimoto and his family hurriedly packed up their lives, leaving behind their home and most of their belongings, including many artworks and supplies.[3] Japanese Americans received instructions to bring only what they could carry: "We were allowed a limited amount of personal belongings—bare necessities—but being an artist, I snuck in art materials, like a few tubes of pigment, three brushes, and a small bottle of turpentine."

The Sugimotos reported to Fresno Assembly Center, not far from their home in Hanford. Before leaving, Susie Sugimoto packed omusubi (rice balls)

1. The approximate total number incarcerated during the war is nearly 120,000, including those born in camps and others not from the West Coast.

3. The entire Tagawa family packed their things away in the building that housed the hand-laundry business, and a European American couple, the Powells, looked after their home and belongings during the war. Although some items were stolen, the Tagawas were, unlike the majority of Japanese Americans, able to retain most of their pre-war property, and they had a place to return to after the war.

2. The literature on the World War II experiences of Japanese Americans is extensive, though not necessarily exhaustive. New information and analysis surface constantly. Many of the published sources are readily available in libraries, bookstores, and other repositories. Among the key historical studies of this period are: *Personal Justice Denied: Report of the Commission on Wartime Relocation and Internment of Civilians* (Washington, DC: Government Printing Office, 1982); Roger Daniels, *Prisoners Without Trial: Japanese Americans in World War II* (New York: Hill and Wang, 1993); and Michi Weglyn, *Years of Infamy: The Untold Story of America's Concentration Camps* (New York: William Morrow & Co., 1976).

55

for the family. After eating lunch, their six-year-old daughter asked, "When are we going home?" Not understanding the circumstances, she thought they had just gone on a picnic and would return home at the end of the day.

Fresno Assembly Center opened on May 6, 1942, and, like all fifteen other assembly centers, lacked adequate facilities for the thousands of evacuated Japanese Americans held there. Previously used as a fairground, Fresno Assembly Center accommodated people in horse stalls and makeshift quarters. Nevertheless, Sugimoto took comfort in the fact that his family, including his parents and brothers, remained together.

From the moment of his arrival at Fresno, Sugimoto resumed sketching and painting, although he worried about surveillance and arrest. Japanese Americans could not bring cameras of any kind into the camps. Under these restrictions, which prevented documentation of treatment and conditions, even artistic representations of life in the camps were considered suspect. Sugimoto's anxiety was outweighed by the sense of purpose he now found: his skill as an artist made it possible for him to record for history the experiences of Japanese Americans in the camps. As he remarked later in life, "I depicted camp life . . . with an artist's sense of mission."[4]

Initially, Sugimoto painted in secret, confining his work to his barracks quarters. In this period his art shifted dramatically from its pre-war focus on landscapes to paintings with a strong narrative theme; at Fresno Assembly Center, he looked back at events leading up to the incarceration and used these as subjects. *Evacuation (One Dollar for a Nice Icebox)* (p. 63) is an early example of Sugimoto's narrative painting. Because of the hurried nature of the mass exclusion, Japanese Americans had no choice but to hastily rid themselves of their possessions. Some people exploited the situation, acquiring valuable items—appliances, furniture, cars—for a small fraction of their actual worth. The painting attempts to relate this experience within the format of a still-life composition.

After Japanese Americans had been in the assembly centers for nearly six months, the government began moving them to concentration camps located in remote regions of the country.[5] Sugimoto recalled, "The government notice

4. Henry Sugimoto, ca. 1981, from personal papers archived at the Japanese American National Museum.

5. In total the government erected ten concentration camps during World War II. They were administered by the War Relocation Authority, a government-run civilian agency.

came to the center that all interned Japanese would move to Jerome Reloca-
tion Center in Arkansas. The time had come when we were forced to ride in
old, old trains that had been out of use for many years. Fresno to Arkansas was
a long way to go. All the windows were draped with black shades, so that we
could not see outside at all. Trains moved slowly, and rattling loud noises woke
us many times at night; some nights we couldn't sleep at all. Water from the
toilet flooded and wet our suitcases and belongings on the train floor."[6] The
internees passed several uncomfortable days on the train, with occasional
stops in deserted areas to stretch and get some fresh air, where "MPs were
lined up with machine guns aimed at us."[7]

The Sugimotos arrived in Jerome Relocation Center in October 1942.
Completely surrounded by snake-infested waters, the camp sat on a remote
region of swampland in southeastern Arkansas. The War Relocation Authority
(WRA) found that the natural dangers of the area created a more effective
boundary than any barbed-wire fence; unlike the other nine camps, Jerome
had no guard towers, and only a low fence demarcated the camp perimeter.[8]

Except for this difference in environment, Jerome resembled most of the
other camps in overall organization. Despite the WRA's pretense of recreating
an ordinary community within the camps, life was anything but normal. Mili-
tary-style barracks, hastily erected with shoddy materials, served as housing
for thousands of Japanese Americans. The barracks were arranged in blocks,
with a mess hall, latrine, laundry room, and recreation hall assigned to each
block. The government provided some basic necessities, but conditions could
hardly be called comfortable. Winter temperatures dropped below zero at
Jerome, and the summer heat and humidity made it an ideal breeding ground
for mosquitoes. Sugimoto found it difficult to find inspiration in the natural
landscape at Jerome, "because in the camp, [there was] no good scenery, just
barracks, that's all. That's why naturally I took as subjects children, everyday
life."[9]

Each barracks room, typically 20 by 16 feet, was occupied by at least one
family. Made from thin planks of wood with a covering of tarpaper, the bar-
racks provided the bare minimum in shelter, and almost no privacy. Sugimoto

6. Henry Sugimoto, draft of
redress testimony given before
the Commission on Wartime
Relocation and Internment of
Civilians in 1981, from personal
papers archived at the Japanese
American National Museum.
7. Ibid.

57

8. Four species of poisonous
snakes inhabited the swampland
surrounding Jerome. Snakes are
a recurring detail in many of
Sugimoto's images.

9. From an interview with
Henry Sugimoto published in
Deborah Gesensway and Mindy
Roseman, *Beyond Words: Images
from America's Concentration
Camps* (Ithaca, NY: Cornell
University Press, 1987).

remarked how people tried to make the best of the situation: "After settling down in designated quarters, we were busy making our room furnishings, such as tables, chairs, shelves, et cetera, out of scrap wood that was piled outside our barracks. Each unit was given bedding and a stove."[10]

Besides adjusting to the physical conditions, Japanese Americans also adapted to social circumstances, establishing organizations and institutions in the camps. Sugimoto took a position as an art teacher in the high school at Jerome. For the first time, he worked with teenagers, imparting his methods and philosophies regarding art. At night he taught adult classes, mostly to fellow issei: "My salary was nineteen dollars a month. The rest of the time I was sketching and painting camp life."[11]

Sugimoto's camp paintings offer considerable factual detail, and close examination reveals the choices that he made in order to represent the emotional, as well as the physical, aspects of incarceration. In *Family in Jerome Camp*, (p. 71) Sugimoto does not show the barracks quarters exactly to scale, even though he has the artistic skill to do so. Instead, he creates a sense of the cramped space in which a young family tries to continue their normal activities— mother sewing, father reading the paper, and children doing homework. Thus, these apparently straightforward subjects do not simply illustrate a daily event; they impart a host of related emotions as well.

Before the war, Sugimoto painted few images of people, concentrating instead on landscapes and still-life subjects. In camp, however, almost all of his compositions include at least one figure, often the focus of the painting. The most common figures throughout Sugimoto's camp work are a woman and child, inspired by his wife, Susie, and daughter, Madeleine Sumile.[12] In *Going to Shower Room* (p. 64), they are pictured going from their barracks to the shower room. Yet the painting is not meant to be strictly a portrait; it is more about the conditions of camp life. *When Can We Go Home?* (p. 77) also includes figures based on Madeleine and Susie. The idea for the work came from a real-life situation, but the woman and child are generalized—in essence, they could be almost any mother and daughter in the same setting.

These depictions of his family convey the consequences of the incarceration

10. Henry Sugimoto, draft of redress testimony given in 1981, from personal papers archived at the Japanese American National Museum. While most of the other camps relied on coal for heat, Jerome inmates chopped and gathered wood from the surrounding area to help warm their barracks. Sugimoto painted several images of Japanese Americans engaged in this strenuous activity.

11. Ibid. The role of artists and art education in the camps is an important area of research within Asian American studies and art history. The most comprehensive text is *The View from Within: Japanese American Art from the Internment Camps, 1942-1945*. Please see the resource list for the full citation and other titles on Japanese American artists during World War II that include information on Henry Sugimoto. Other important publications on individual artists include: Kimi Kodani Hill, *Topaz Moon: Chiura Obata's Art of the Internment* (Berkeley: Heyday Books, 2000); Estelle Peck Ishigo, *Lone Heart Mountain* (Los Angeles: Anderson, Ritchie & Simon, 1972); Miné Okubo, *Citizen 13660* (Arno Press, New York, 1946).

12. Sugimoto's daughter is named Madeleine Sumile Sugimoto. While she has an English first name, her parents referred to her by her Japanese name, Sumile. In titles of works and in quotes from Sugimoto, the name Sumile is used.

58

on women and children powerfully, but of course Sugimoto did not see his wife and daughter simply as symbolic models. As a father and husband, he felt responsible for his family and frustrated at being unable to shelter them from the circumstances: "In camp, suddenly life changed. I feel so bad, because I'm married too [with a child]. How many years will life continue like this?" In a poignant reflection on his family, Sugimoto painted individual portraits of Madeleine and Susie *(At Fresno Assembly Camp Sumile Was Six Years Old* and *Susie,* pp. 79 and 80). In contrast to other works where the two appear as generalized figures, these portraits are startling in their detail and the emotion they convey.

Sugimoto also painted a portrait of his mother during her incarceration, *Mother in Jerome Camp* (p. 81). In the painting she appears to be weary and aged, though she was only in her sixties at the time. The fact that she is in camp certainly accounts for the somber mood of the image. The background details of the work explain the circumstances of the painting. To the left is a U.S. flag with a star and a V-for-victory symbol, while on the shelf to the right is a photograph of a soldier. Below that is a cloth with other military symbols and division markings. All of these items relate directly to Sugimoto's younger brother, Ralph, who volunteered for the U.S. Army in late 1943. He became a member of the 442nd Regimental Combat Team, an all-nisei unit that fought valiantly in the war. Ralph's enlistment naturally had a tremendous impact on the entire family, in particular Sugimoto's mother. Painted in 1943, *Mother in Jerome Camp* is a prime example of Sugimoto's increased range and complexity, in terms of both subject matter and style, during this period.

These examples illustrate not only Sugimoto's technical skill at capturing an individual's likeness, but also his ability to sincerely communicate a range of feelings and issues through portraiture, a relatively new genre for him. During the remainder of his incarceration, Sugimoto would challenge himself further, tackling difficult and controversial issues in his life and art.

Attacked Pearl Harbor, 1947
Oil on canvas, 22 ½ x 19 inches.
(92.97.74)

"I . . . turned on the radio and heard them say, 'A Jap bomber squadron has bombed Pearl Harbor; there are many casualties, and many American battleships have been destroyed.' . . . What was going to become of us Japanese? What were we to do?"

When the United States entered World War II, the lives of many Japanese Americans were torn apart. Sugimoto's work after 1941 shows a dramatic transition from landscapes and still-life paintings to powerful narratives focusing on this experience.

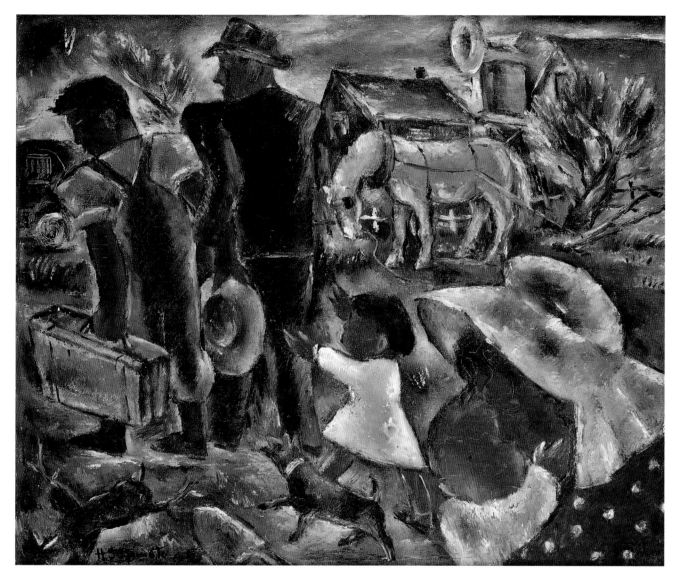

My Papa, 1943
Oil on canvas, 18 x 21¾ inches
(92.97.91)

"The Japanese-language newspaper reported daily that
Japanese who lived all over [the West Coast] were
being taken by the FBI."

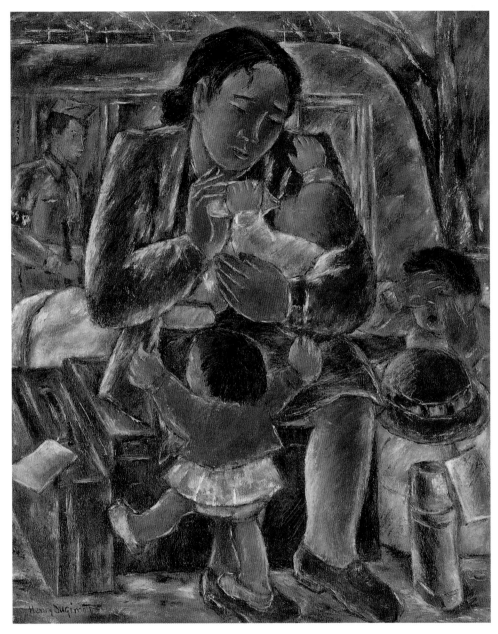

At the Fresno Assembly Center, Sugimoto had few art supplies, which accounts for his limited palette and predominant use of brown in paintings from this period. Despite his lack of materials, he experimented with composition, taking inspiration from the works dominated by imposing figures that he had seen in Mexico. In this painting, for example, a mother and her children are the central focus, while in the background a soldier provides a reminder of the circumstances of evacuation.

Untitled, 1942
Oil on canvas, 24¼ x 19¾ inches
(92.97.69)

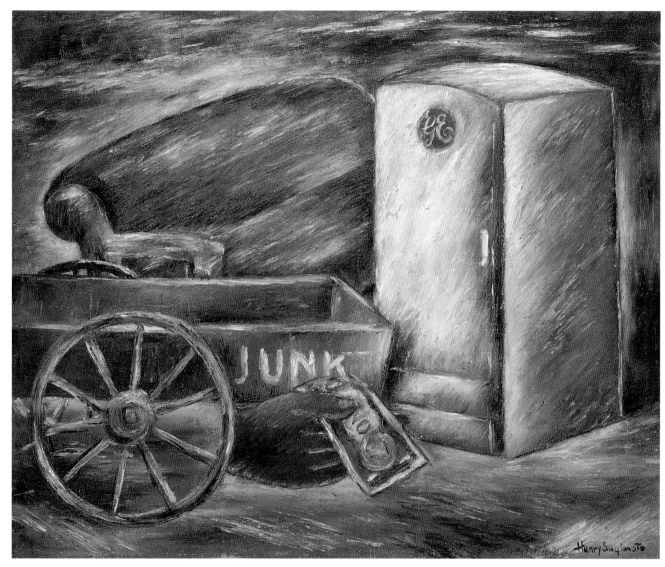

Evacuation (One Dollar for a Nice Icebox), 1942
Oil on canvas, 20 ½ x 25 ¾ inches
(92.97.82)

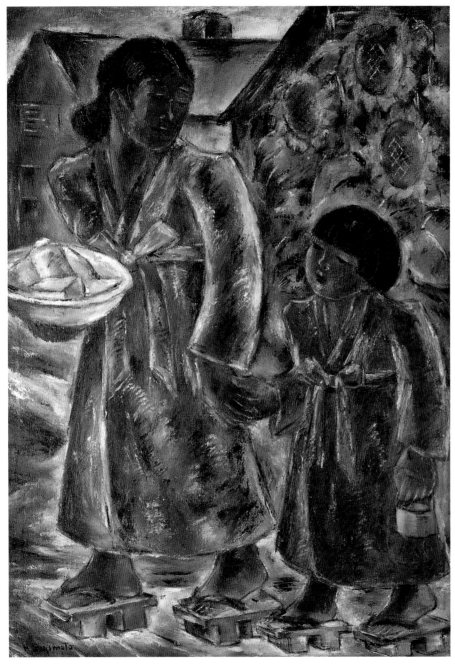

Sugimoto feared that his paintings of camp life would arouse suspicion. In a 1982 interview (published in *Beyond Words: Images from America's Concentration Camps*) he recalled, "First time, I was scared. Maybe the FBI is [looking] at me painting, and I will be taken away."

Going to Shower Room in Fresno Assembly Center, 1942
Oil on canvas, 31¾ x 22¾ inches
(92.97.86)

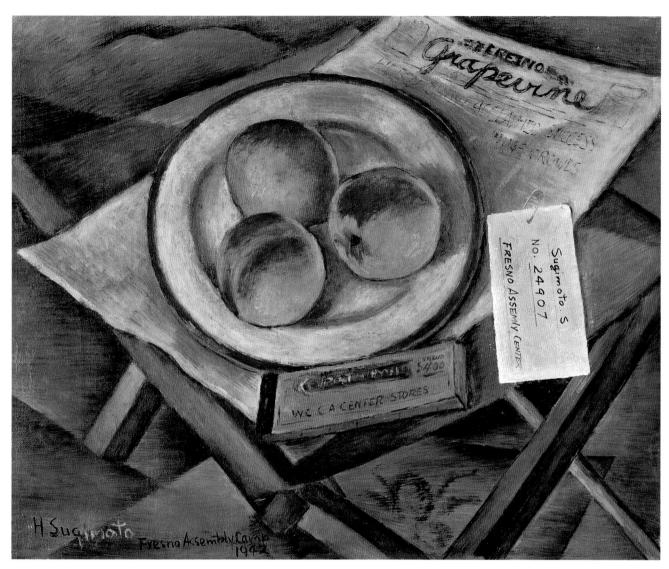

Fresno Assembly Camp, 1942
Oil on canvas, 13 x 16 inches
(92.97.67)

An apparently simple still life tells a complex story. An innocuous plate of peaches sits beside several other objects: a copy of the *Fresno Grapevine* (a newspaper produced by Japanese Americans in the camp); the government-issued tag that identified the Sugimotos by their assigned number— 24907; and a ration booklet that could be used to purchase items at the camp cooperative.

Sketches made on the train from the Fresno Assembly
Center to Jerome concentration camp, 1942
Pencil on paper, 4 x 6 inches
(100.2000.1)

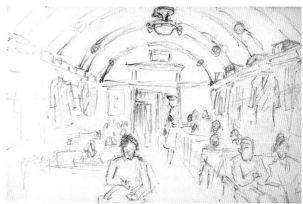

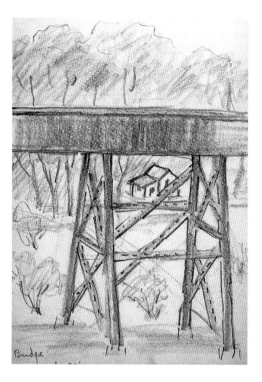

Bridge

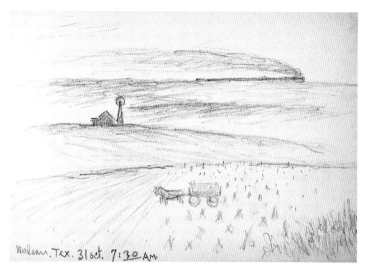

McLean. Tex. 31 oct. 7:30 AM

"We were forced to ride in old, old trains that had been out of use for many years . . . Fresno to Arkansas was a long way to go."

Henry Sugimoto, draft of redress testimony given in 1981

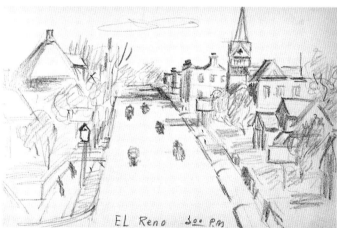

EL Reno 3.00 P.M

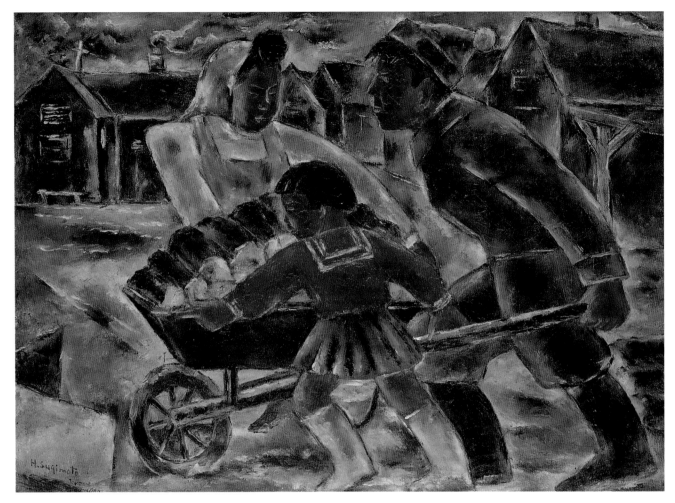

In Winter of Jerome Camp, 1943
Oil on canvas, 32 x 24 inches
(92.97.90)

While most of the other camps relied on coal for heat, Jerome inmates chopped and gathered wood from the surrounding area to help warm their barracks.

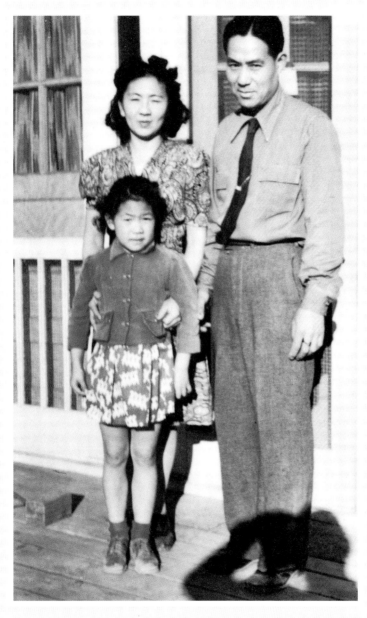

Susie, Henry, and Madeleine in front of their barracks at
Jerome concentration camp in Arkansas, ca. 1943.
(2000.381.10)

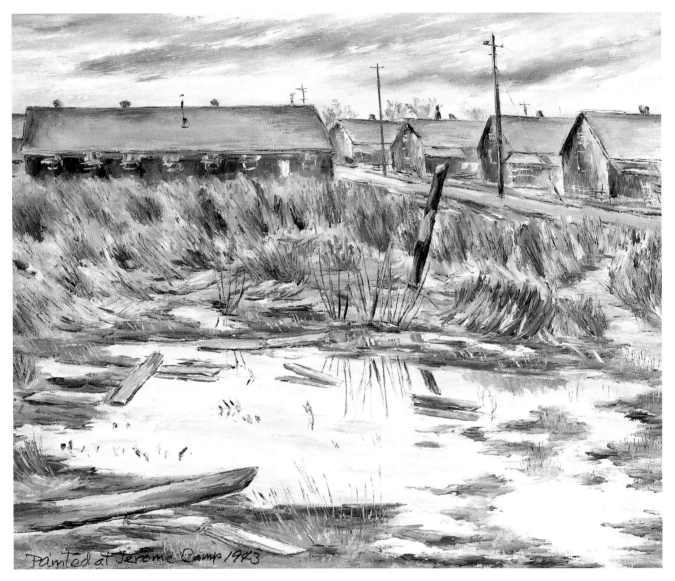

Jerome Camp, 1943
Oil on board, 17¾ x 21½ inches
(92.97.65)

"Staying in the camp, I had no chance of contact with the
outside. . . . Sometimes I went into the wooded area within
the confines of the camp. I created imaginary landscapes of
Arkansas, beautiful autumn scenes . . . [of the] surrounding
[area], as much as I could see from the camp."

From a 1986 interview with Henry Sugimoto by Boris Musich

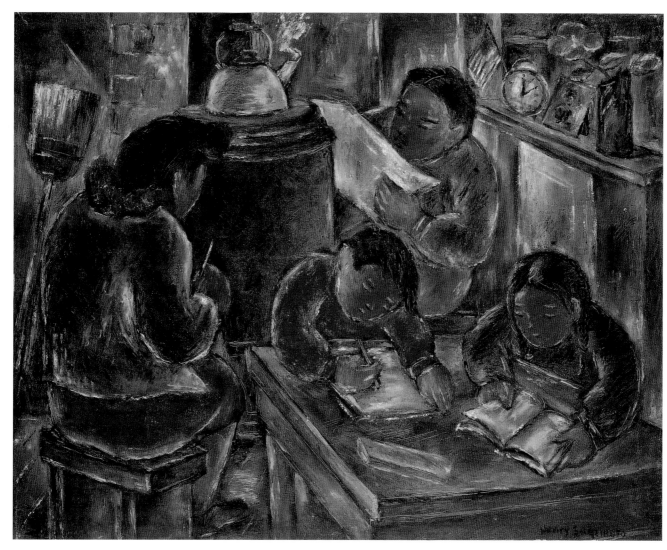

Family in Jerome Camp, 1942
Oil on canvas, 23 ¾ x 40 inches
(92.97.88)

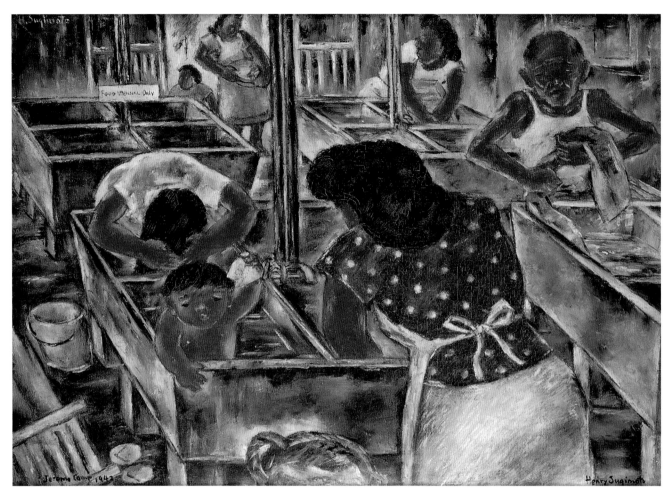

Our Washroom, Jerome Camp, ca. 1943
Oil on canvas, 22¾ x 31¾ inches
(92.97.47)

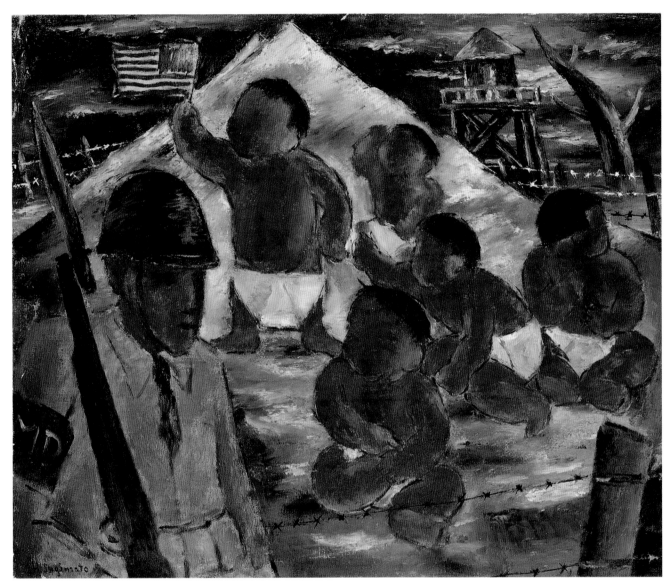

Nisei Babies in Concentration Camp, 1943
Oil on canvas, 18 x 22 inches
(92.97.130)

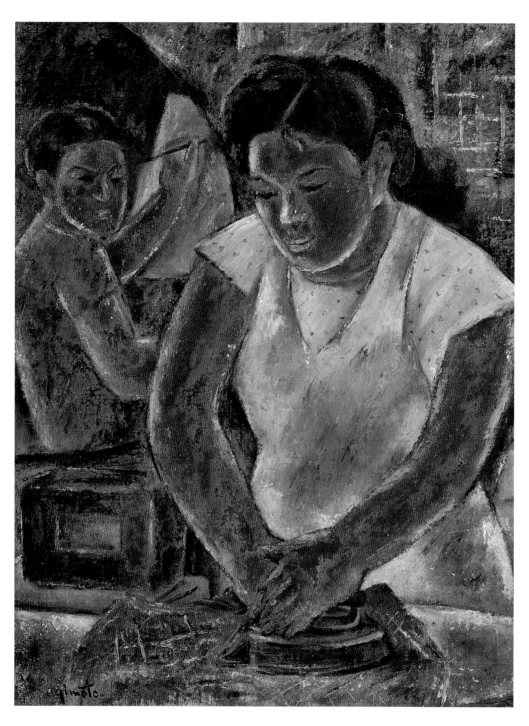

Susie in Camp Ironing Room, 1943
Oil on canvas, 23 ¾ x 19 ¾ inches
(92.97.84)

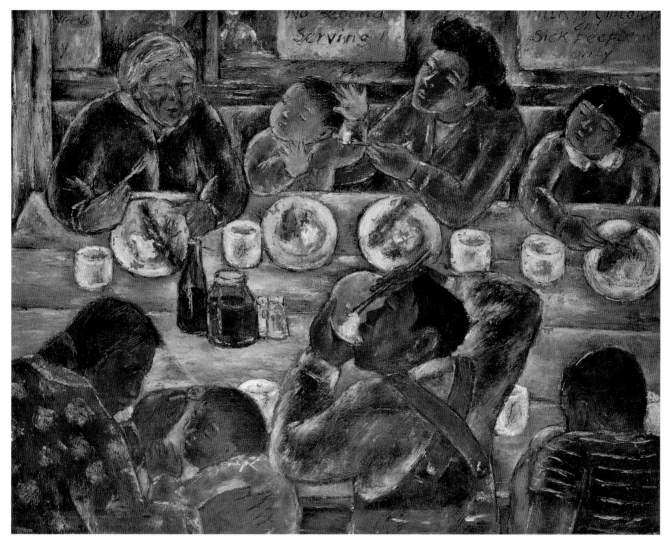

Our Mess Hall, 1942
Oil on canvas, 24 x 30 inches
(92.97.56)

"Of course, it was impossible to be picky about what you wanted
to eat. They knew that the Japanese really liked rice, so rice was
always a part of the menu at least once a day. However, there
were times when the rest of the meal didn't really go with rice.
At times, there would be food that just wasn't appetizing at all,
so you had to either try to eat at least one bite or just go without
the meal."

76

The painting on the opposite page represents a surprising departure from Sugimoto's usual style and suggests the influence of cubism as well as Mexican murals. The painting is fractured by a dramatic lightning bolt. To the left are architectural symbols of California, representing Sugimoto's life before World War II. To the right are a guard tower and a camp mess hall. Below are a log, axe, snake, and sunflower, all items likely to be found in camp. At the center of the painting stand a woman and child, inspired by Sugimoto's wife and daughter, Madeleine. The title is a question posed by Madeleine to her parents when they were first confined to Fresno Assembly Center. Later, Sugimoto retitled this composition *Longing,* after a work that the poet John Gould Fletcher wrote in response to it.

When Can We Go Home?, 1943
Oil on canvas, 32^1/$_2$ x 23^1/$_4$ inches
(92.97.3)

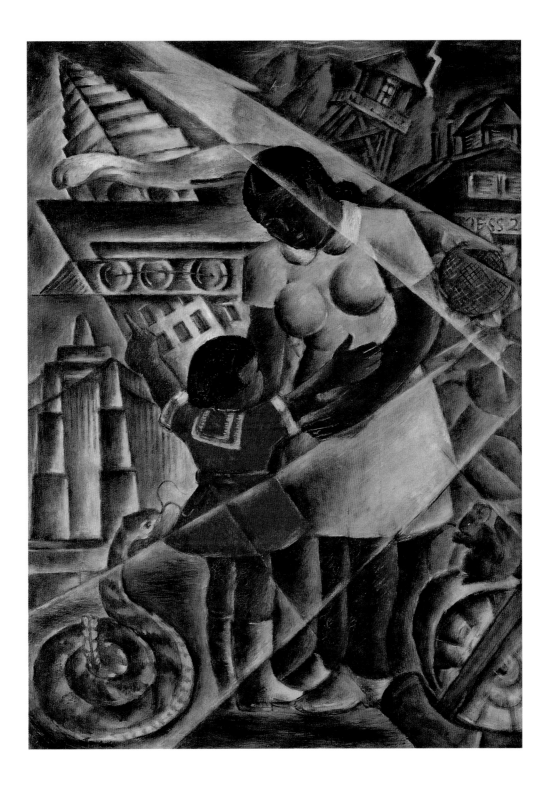

78

In contrast to documentary works with generalized figures, some of Sugimoto's paintings from this period are skillfully executed likenesses, rich in emotional content.

Henry and Susie Sugimoto pose in front of their barracks in Jerome concentration camp, 1943. A palette-shaped sign above the doorway identifies the Sugimoto quarters as the home of "Henry Sugimoto—Artist."
(93.131.5)

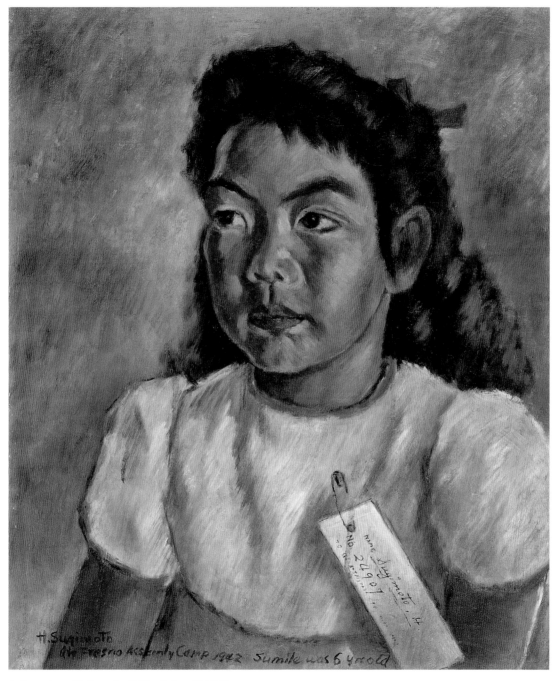

At Fresno Assembly Camp Sumile Was Six Years Old, 1942
Oil on canvas, 18 x 14 3/4 inches
(92.97.68)

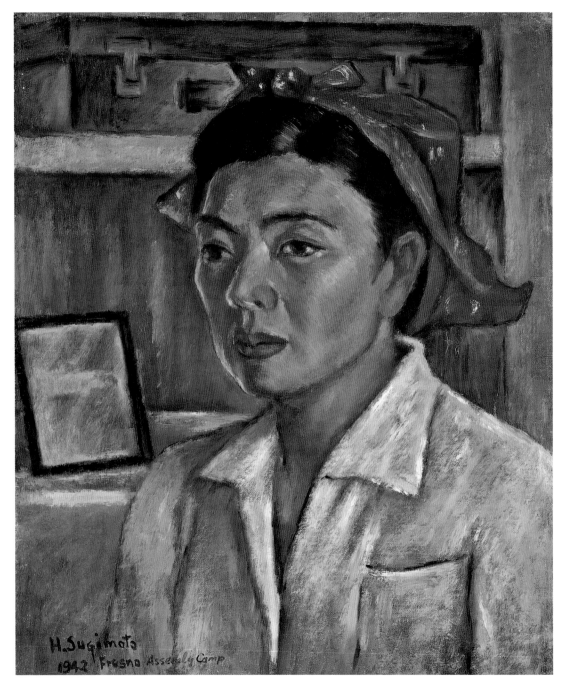

Susie, 1942
Oil on canvas, 17 3/4 x 14 3/4 inches
(92.97.132)

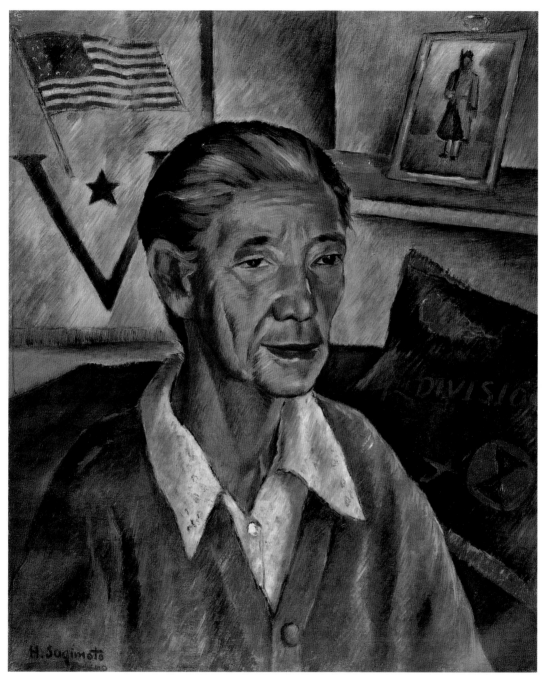

Mother in Jerome Camp, 1943
Oil on canvas, 22 x 18 inches
(92.97.7)

A LIFE TRANSFORMED

1941 – 1945

DURING HIS INCARCERATION, Sugimoto maintained very little contact with the outside world in general, and even less with museums and galleries. Up until the bombing of Pearl Harbor, his work had been shown consistently in exhibitions and galleries; then, seemingly overnight, that activity came to a halt. Sugimoto's *Self Portrait in Camp* (p. 89) makes a profound statement about his determination to continue as an artist during this period. Everything in the painting—palette, easel, canvases, beret—proclaims his identity as an artist. The context of camp, so undeniably stated in almost all other paintings from this period, is notably absent here. Sugimoto instead paints himself in an artist's studio, surrounded by the paintings he is most proud of—his body of work from France. In this, his only self-portrait during the war, Sugimoto presents himself not as a man incarcerated, but as a serious artist.

In a short period, Sugimoto's work had shifted dramatically, from innocuous landscapes to emotionally and politically charged works that responded directly to the circumstances of his incarceration. While these changes suggest tremendous artistic growth, it is crucial to recall that at the time Sugimoto believed his career as an artist to be over: "When World War II broke out, we

1. From an interview with Henry Sugimoto by Boris Musich, 1986.

Japanese were confined to the concentration camps. I thought that my artist life was finished."[1] Although he painted to leave a record for the future, Sugimoto had no idea what the outcome of the war would be, or what would happen to Japanese Americans in the months to come.

In addition to concerns about his future career, Sugimoto continued to worry about the consequences of his painting in the present. While he did not hide the fact that he was an artist, he concealed his work from authorities for fear of the consequences of being found depicting scenes of camp life. But when the authorities learned of the work, they did not confiscate the paintings or try to stop Sugimoto. Instead, they decided to use the work to illustrate the "freedom" enjoyed by incarcerated Japanese Americans. A government official documented Sugimoto's paintings on film, in still photographs and in moving images. A filmmaker directed Sugimoto and his wife. "He told me, 'We want to take movies. You do your work and your wife will bring you some tea.' So me and my wife—like actors. Then they took [more footage] in the mess hall . . . on the corner table, so much food, chicken [and things] we never ate here before."[2] Sugimoto understood the purpose of the film, given the staging of the shoot. "I asked the lieutenant, 'What are you going to do with these movies?' [He replied], 'That's a government record [to show how] we treat Japanese . . . very freely.'" Sugimoto had no control over the propagandistic purposes of the film, but he managed to take advantage of the circumstances. If the government could use him to abstract the notion of freedom in the camps, then he would exercise his rights and paint freely.

Sugimoto's position as the camp's high-school art instructor enabled him to requisition art supplies—real canvas and oil paints. Before, he had scavenged from junk piles, recycling materials such as bed sheets and scraps of wood to create working canvases. Now, possession of these basic materials, combined with the freedom to paint openly, made it possible for Sugimoto to produce a more extensive body of work. He made his identity known throughout camp by hanging a palette-shaped sign above the door to his barracks—on it he painted the title "Artist."

Now that he was recognized officially as an artist, Sugimoto's work began

2. From an interview with Henry Sugimoto published in Deborah Gesensway and Mindy Roseman, *Beyond Words: Images from America's Concentration Camps* (Ithaca, NY: Cornell University Press, 1987).

to receive recognition from sources outside of camp. In 1943, a group from Hendrix College in Conway, Arkansas, visited Jerome. A member of the art faculty, H. Louis Freund, viewed some fifteen paintings by Sugimoto on that trip and immediately made arrangements with Jerome's director for an exhibition of these works at the Hendrix College art gallery. In February 1944, Henry Sugimoto exhibited—for the first time outside of Jerome—paintings representing life in one of America's concentration camps. With the United States still at war, the college carefully crafted its press release, describing Sugimoto and his family as "loyal Americans and members of the Presbyterian [Church]." The artworks on view were said to "contain no suggestion of bitterness" and to be "marked by tenderness and occasional humor."

Escorted by Jerome's director, Henry and Susie Sugimoto attended the opening of the exhibition at Hendrix College. There they met students and faculty who praised the work and its message. This outside encouragement confirmed for Sugimoto the existence of an audience receptive to the subject matter of the paintings. In addition, the presentation of his art in a gallery setting allowed Sugimoto to again think of himself as a practicing artist.

In the absence of interference from the camp administration and with outside encouragement, Sugimoto began to take up controversial issues in his art. His images of the mess hall and gathering wood offered commentary on everyday life in camp, but the more complex political issues of incarceration did not surface in Sugimoto's work until 1943. Early that year, the WRA mandated the "registration" of Japanese Americans through a questionnaire issued to all issei and to nisei over the age of seventeen. Two key questions led to mass confusion, distress, and fear at all ten WRA camps:

> Are you willing to serve in the armed forces of the United States in combat duty wherever ordered?
>
> Will you swear unqualified allegiance to the United States of America and faithfully defend the United States from any or all attack by foreign or domestic forces, and forswear any form of allegiance or obedience to the Japanese emperor, to any other foreign government, power or organization?

Both questions underscored fundamental issues of citizenship and loyalty, spotlighting the government's unjustified suspicions that Japanese Americans were disloyal to the United States. No one could predict what would happen during the course of the war, and no one knew how their answers to the questionnaire might affect their own futures. Issei, incarcerated by a government that would not allow them to become naturalized citizens, found themselves caught in a dilemma: if they answered "yes" to the latter question, they essentially surrendered the only citizenship they had, while incarcerated by a government that denied them the ability to become naturalized citizens; if they answered "no," they feared they would suffer consequences even worse than incarceration. Nisei, who had been rejected for military service earlier in the war because of their presumed disloyalty, regarded the first question as an insult. The government's hypocrisy both baffled and angered them—how could they be asked to fight for a country that denied them their rights as citizens? Why did the government question their loyalty when Italian and German Americans did not have to prove their allegiance?

Ultimately, Japanese Americans fell into two broad categories, those who answered "no-no" and those who stated "yes-yes." Emotional responses varied greatly among individuals and families, and discord that already existed in the camps came to the surface. Those who answered "no" to both questions were regarded by the government as well as other Japanese Americans as disloyal, and they suffered arrest, persecution, and segregation. On the other extreme, those who vehemently proclaimed "yes" to the questions were seen by some— especially kibei men—as informants for the government.[3] The government treated kibei with even greater suspicion than their nisei counterparts because they had spent a significant part of their youths in Japan. Often singled out in camp as disloyal troublemakers, kibei became even more vocal about defending their rights when the loyalty questionnaire surfaced.

At Jerome this conflict manifested in physical violence. Reverend John Yamazaki, a prominent member of the Christian community, often translated English documents, usually U.S. government items like the questionnaire, into Japanese for the sake of the issei and kibei population. Some kibei believed

3. Kibei is a term used to describe Japanese Americans born in the United States and then sent to Japan by their issei parents for their education. Upon returning to the United States, kibei found themselves out of step with their nisei peers. In particular, kibei felt most comfortable with the Japanese language as opposed to English.

that Reverend Yamazaki not only worked for but colluded with the government against fellow Japanese Americans. This led to his being attacked in early March 1943. News of the beating spread throughout camp. Sugimoto wrote, "While I did not witness this beating, I read about it in the modest mimeographed newspaper that related camp events, which also printed the waka [a type of Japanese poem] that Reverend Yamazaki had composed as a response to the beating. I began to envision [the incident] as the subject of a documentary painting."

Reverend Yamazaki Was Beaten in Camp Jerome (p. 93) is one of Sugimoto's most powerful works. In the painting, one man holds the minister by his arms while the other is about to strike a blow. The minister's pose is undeniably a reference to the crucifixion of Christ. Years later, Sugimoto contacted Reverend Yamazaki to request a copy of the waka and provided him with a photograph of the painting. The minister wrote back, noting the inaccuracy of some of the details: ". . . The two or three students who beat me said, 'Reverend Yamazaki, we came here to beat you, so take off your glasses and hat and put them on this tree stump.'" Sugimoto added the waka to the painting but left the rest as he had originally done it: "It was unavoidable that there were some discrepancies, since I had not witnessed the beating incident and was painting from my imagination."

In June 1944, the WRA closed Jerome, transferring Sugimoto and others to the Rohwer concentration camp. Also located in southeastern Arkansas, Rohwer shared the climate and basic conditions of the Jerome site. At Rohwer, Sugimoto continued to paint subjects that reflected his own family's experiences. With his younger brother in the U.S. Army, Sugimoto paid close attention to the situation of nisei soldiers. In numerous compositions he pictured soldiers saying goodbye to their families left behind in camp. In other works he demonstrated sympathy for elderly issei parents who, like his own, were filled with worry for their sons on the battlefields.

By the summer of 1945, as the war came to an end, Sugimoto found he had completed over one hundred paintings, in addition to numerous sketches chronicling three and a half years in camp. Now free to go, people began

87

leaving Rohwer en masse. Faced with the need to decide whether or not to return to California, Sugimoto and his family began to make plans to go to New York City. "Susie's parents were going with her younger sister back to their old home in Hanford, and my parents decided to go live with my brother who had gone to Cleveland. . . . [As] an artist, I had already been wanting to move to New York City when I was living in California, and so I thought that this was a good opportunity to go." In one last stroke of bad luck, Sugimoto had an attack of appendicitis, and the move took place while he was still recovering from surgery. But finally, just days before the official end of the war, the Sugimotos left Arkansas. Completely free for the first time in three and a half years, they were also completely alone; on their own, they were about to begin a new life in New York.

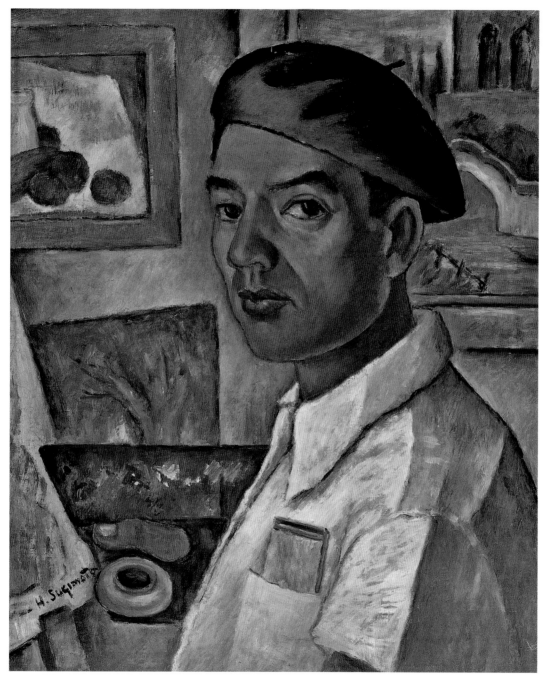

Self Portrait in Camp, 1943
Oil on canvas, 22 x 18 inches
(92.97.5)

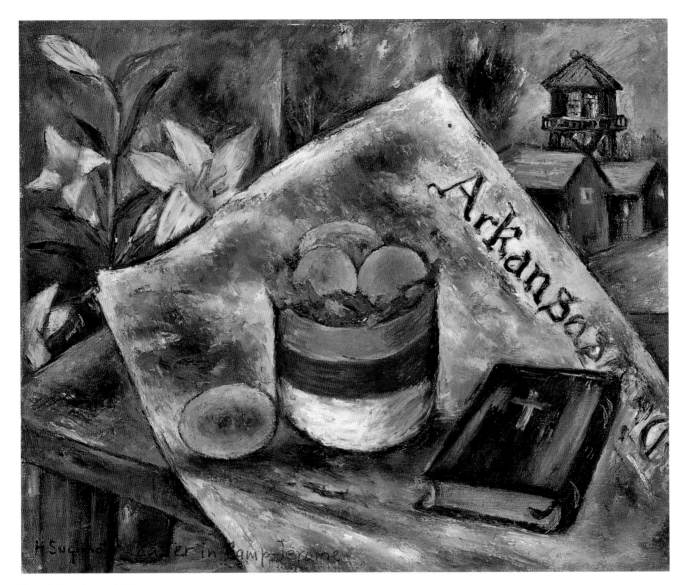

Easter in Camp Jerome, 1942
Oil on canvas, 13 1/4 x 16 inches
(92.97.66)

Sugimoto was baptized in the 1920s and sustained a deep faith for the rest of his life. He wrote, "Dislocation, moving from one place to another, was indeed depressing and trying . . . this condition could be persevered by looking up and knowing that Christ has His heavy cross to bear."

Henry Sugimoto, ca. 1981, from personal papers archived at the Japanese American National Museum

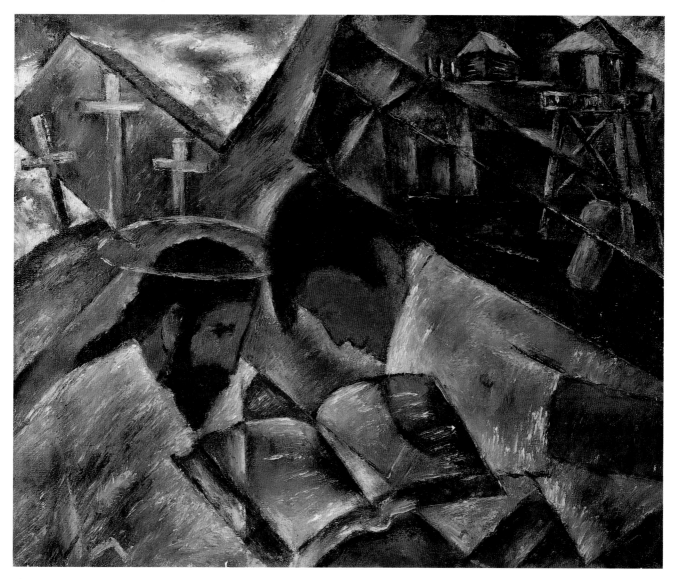

Thinking About Christ, 1943
Oil on canvas, 19 ¼ x 23 ¾ inches
(92.97.83)

In 1943, members of the Hendrix College art faculty visited Jerome and decided to mount an exhibition of Sugimoto's work at the college. Accompanied by a WRA administrator, Sugimoto and his wife spent a few days outside the confines of camp to attend the opening.

Henry and Susie Sugimoto at the opening of a one-person exhibition at Hendrix College in Conway, Arkansas, in February 1944.
(93.131.39)

92

"While I did not witness this beating, I read about it in the [camp] newspaper . . . which also printed the waka [poem] that Reverend Yamazaki composed as a response to the beating. I began to envision the beating as the subject of a documentary painting. When I moved from camp to New York City . . . I added [the poem to an] empty part of the canvas":

> When I received the blow I felt as
> My own child hitting me, for they
> Were my own kind—
> Each blow reminded me of God's will
> Who taught me of my own lack of suffering.

Reverend Yamazaki Was Beaten in Camp Jerome, 1943
Oil on canvas, 39 1/4 x 30 1/4
(92.97.6)

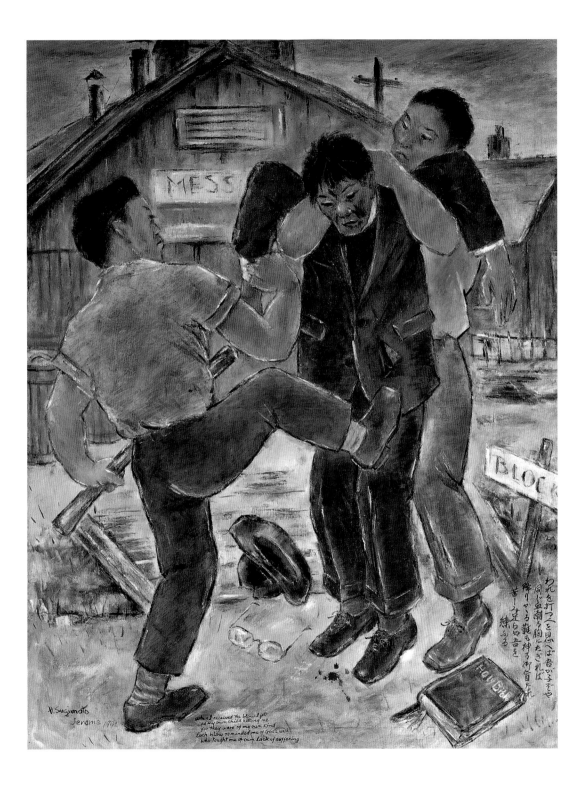

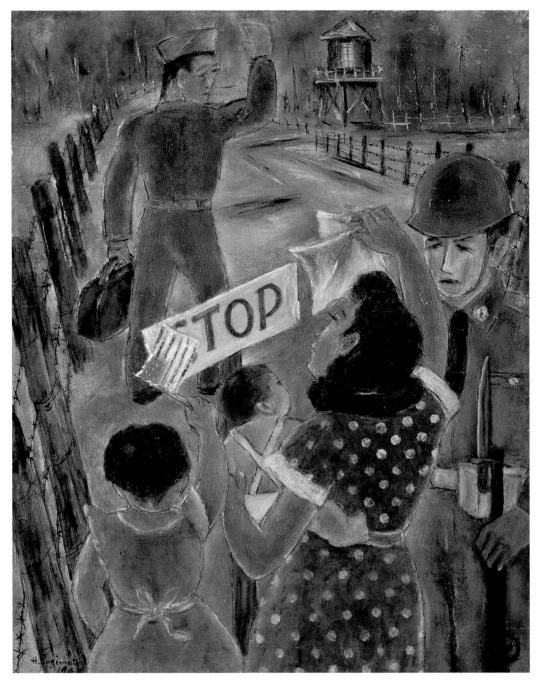

Sending off Husband at Jerome Camp, ca. 1944
Oil on canvas, 30 x 23½ inches
(92.97.1)

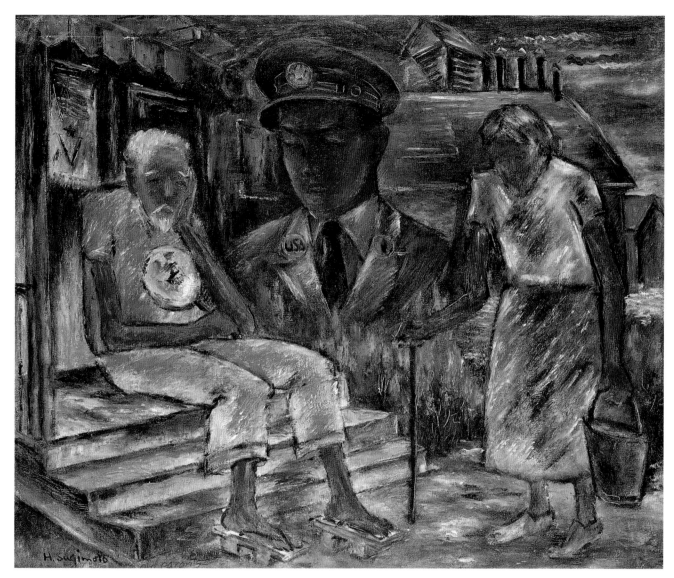

Old Parents Thinking About Their Son on the Battlefield, 1944
Oil on canvas, 19¾ x 24 inches
(92.97.4)

"One of the nisei soldiers who willingly enlisted under the draft law came
back to say goodbye to his parents in the camp. There was so much to learn
from his words in answer to his friends' questions—he said he knew too well
that U.S. policy towards Japanese Americans is unreasonable, but he cannot
be angry. It is the time to sacrifice and serve . . . with the hope that risking
life may become the driving power to shatter ignorance."

Henry Sugimoto, draft of redress testimony given in 1981

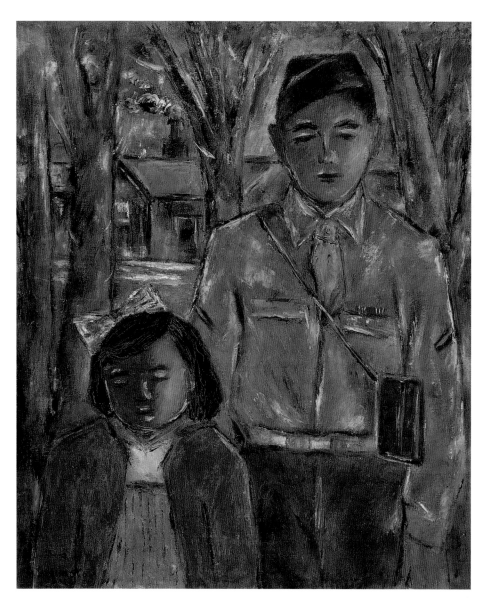

Uncle Ralph and Sumile in Camp Jerome, 1943
Oil on canvas, 25 x 20 ½ inches
(92.97.79)

"My younger brother Ralph went into the U.S. Army. He fought
on the European battlefield as one of the 442nd battalion. He
was injured and received a Purple Heart. . . . These nisei soldiers
in the 442nd fought for their native land and also for the future
welfare of all Japanese in this country."

Henry Sugimoto, draft of redress testimony given in 1981

Issei mothers prepared
their sons for war by
creating a senninbari,
a protective talisman
made of cloth. An image
is sewn onto the fabric,
with a thousand stitches
done by many women
throughout the camp.
Sugimoto's sympathy
for both nisei solders
and their issei parents
is evident in this work.

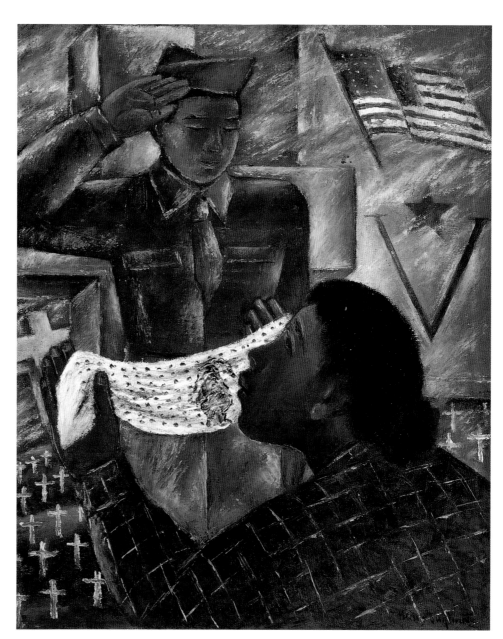

In Camp Jerome, 1943
Oil on canvas, 25 x 20½ inches
(92.97.9)

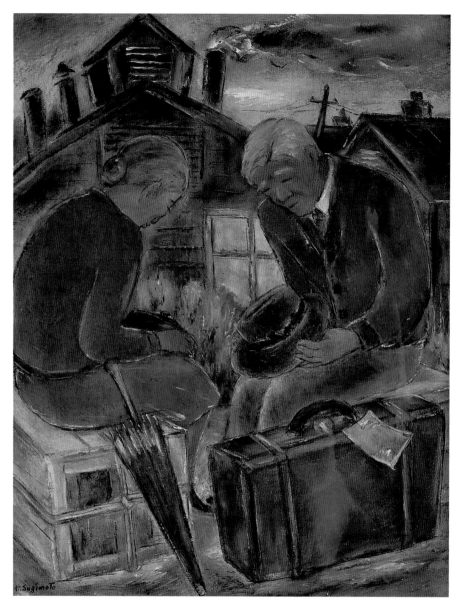

Praying for Safety, ca. 1945
Oil on canvas, 29¼ x 23 inches
(92.979.44)

"Would you join me in a silent prayer for the loving memory of
those young nisei soldiers who died on the battlefield, and also for
those immigrant issei who died here in the U.S., who worked so
hard to raise children under such painful actions against them?"

Henry Sugimoto, draft of redress testimony given in 1981

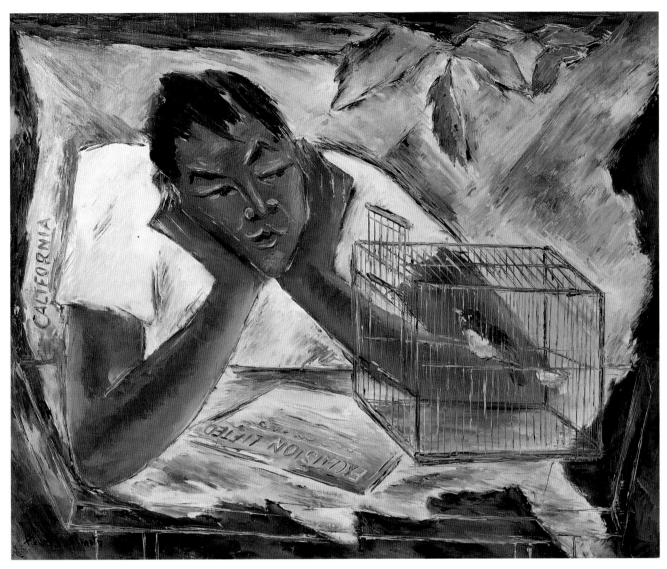

Freedom Day Came, 1945
Oil on canvas, 21¼ x 25¼ inches
(92.97.73)

RE-ENVISIONING HISTORY

1945 - 1990

N AUGUST 1945, the Sugimotos got off a train in New York City, anxious to get a fresh start in a new place. Like most Japanese Americans leaving the concentration camps, they soon realized that the life they had before the war was gone forever, and it would be no simple task to reestablish themselves. With very little money, the Sugimotos managed to get a one-bedroom apartment in the city. For the first month they could not afford electricity or furniture. Slowly they managed to get some bare necessities, including a small used bed that Susie and Madeleine slept on. Sugimoto recalled, "While I needed to make money somehow, I ran into barriers. My wound from my operation hadn't healed yet, and if I couldn't sell the paintings I had done in camp, we had no source of income." Having found that none of his contacts in the New York art world were interested in his camp paintings, Sugimoto began to feel desperate.

Prejudice compounded their difficulties. Even with the war over, they were looked upon as the enemy. "When we left camp, the WRA gave us ration tickets for meat and sugar, but when we went to the local store to buy sugar, because we were [looked at as] foreigners . . . they wouldn't sell to us. Of course, it was the same with meat." For the first month the Sugimotos managed to live on some bacon they brought with them from camp. "My uncle worked in the

mess hall in camp, and he said that it might be hard to buy meat once we left, so [he gave us] a pound of bacon. We used this sparingly, making soup stock from it . . . and luckily we were able to buy rice . . . so we added spinach or occasionally mackerel or some other fish to rice. We were thankful that we were able to cook three meals a day in our apartment."

Although they managed to survive this way for a few weeks, the little money they had began to run out. Down to their last few dollars, the Sugimotos received a fortunate visit. "At this lonely time, by what must have been God's will, Reverend Harper Sakaue, who had been the Japanese Christian Church minister in camp, stopped by one evening, completely out of the blue . . . I told him of recent events and briefly explained our current living situation and finally told him about how we had no more money." Reverend Sakaue made arrangements for Susie to work as a typist at the Baptist church headquarters. "From that point, Susie was able to receive $25 a week, and while this wasn't enough, now that we were getting some money, we were very relieved. My wife went to work every day, and my daughter, Sumile, entered a public elementary school, and I stayed at home and became the cook, and meager as it was, we had finally started our life in this great city of New York."

After a number of temporary jobs, Sugimoto eventually found steady work at a textile company, creating fabric patterns. He did not enjoy the repetitive nature of the job, but it supported the family for years. During whatever spare time he could find, he continued to work on his art. New York City offered a whole new landscape to paint, and he explored the city's many picturesque spots. He also took advantage of the active art scene, visiting museums and galleries as often as possible. These visits offered exposure to a seemingly limitless array of artistic styles, prompting Sugimoto to experiment with his own way of painting. Works from this period have shallow, almost two-dimensional backgrounds, and natural forms, including human figures, are exaggerated. This was a departure from his usual representational style, which aimed to show objects in three-dimensional space.

Living in New York City provided Sugimoto and his family, now including son Phillip, born in 1949,[1] with numerous opportunities for entertainment.

1. Phillip died tragically in 1972. Sugimoto included Phillip, as he did Madeleine, among the subjects of his artwork.

From their apartment on West 146th Street in Harlem they traversed the city, going on picnics, visiting friends, and attending church-sponsored events such as baseball games. Perhaps owing to their middle-class status and their initial financial struggles after the war, Sugimoto always insisted on walking everywhere, occasionally taking the subway but never riding in a cab. By the 1960s they had firmly established themselves in New York, accumulating a large network of friends both within and outside of the Japanese American community.

In 1962, at the age of 62, Sugimoto retired from his job at the textile company in order to devote himself completely to art. He later said that he had told his boss, "Until the war I succeeded as an artist, and I want to take this opportunity—even though I may be old—to return to the path of an artist." It was time for a change: "I felt that this was the time to stand up, and if I didn't do this now, I would be dragged down by my work, and my life would continue without meaning until I grew old and my life ended." He believed the way to invigorate himself and to regain the momentum he had enjoyed in the 1930s would be to return to France, the place that had offered so much inspiration at the start of his career. His wife assured him that she would manage the household while he was away, and with his family's blessing, Sugimoto spent a year in France, this time focusing on Paris with brief visits to the countryside. He sketched and painted many familiar sites, though he found France had changed a great deal during the war. Of course, Sugimoto had himself undergone a transformation during the war years. Perhaps, with the passionate engagement and sense of mission he had gained during the war, he could no longer be captivated by the landscapes of France. While the scenery no longer held the same magical charm, he enjoyed reuniting with old friends who had made France their permanent residence.[2]

After a year in France, Sugimoto decided to delve even further into the past and went to Japan to visit relatives and friends he had not seen since leaving more than forty years before.

Japan, like France, had changed a great deal during and after World War II. Sugimoto caught only a fleeting glimpse of the countryside of his childhood: "The ancient pine trees that had surrounded the village to the north as well as

2. In particular, Sugimoto enjoyed visiting artist and long-time friend Leonard Tsugouharu Foujita (1886–1968). The two met as young men, sharing a passion for art though their particular styles and interests differed significantly. Both emigrated from Japan, Sugimoto to the United States and Foujita to France. They visited one another several times throughout their lifetimes and seem to have corresponded on a regular basis.

the small hill on which they grew had been leveled, and nothing remained. And the white sandy beach where, on a clear day, it had been possible to see as far as Awajishima and Shikoku was now so covered with factories that it was barely visible. And there were fences to keep out unauthorized people . . ." He nevertheless enjoyed the reunion with his aunt and uncle and met many relatives on this trip. In many ways the visit confirmed for Sugimoto the extent to which America had become his home. [3]

During his visit to Japan, Sugimoto met with Terada Takeo and Togo Seiji, both artists and influential members of the Nikakai, a Japanese artists' group. Terada and Togo urged Sugimoto to submit work for the Nikakai's annual exhibition, "but I did not have a painting with me that I could submit to Nika, so I said that I would return to New York City and paint a work . . . and send it to him if it turned out well." Once back in New York, Sugimoto began working on two new pieces, *People Who Live Along the Seine* and *Arrival at Jerome*. The first was a French scene, while the latter was a reworking of a painting done in camp. Pleased with both, he sent them to Japan for consideration. Terada wrote back, explaining that since paintings that had to do with the war still weren't well received by the Japanese public, he had submitted only *People Who Live Along the Seine*. Nikakai accepted this painting and invited Sugimoto to become a member, making it possible for him to show work annually in Japan: ". . . Many artists in Japan submit to Nika every year and have a hard time being made a member. [The fact] that I who live in America . . . and am an American painter was standing on the grand stage of the Japanese art world was something to be celebrated."

In the United States as well, Sugimoto began to show his work in galleries and small group exhibitions. More often than not, exhibition organizers chose his French scenes and urban landscapes of New York rather than his camp paintings. From the late 1940s on, Sugimoto had spent considerable time reworking compositions from camp, in some cases on larger canvases and often in a slightly brighter palette, and he had also developed new compositions based on his camp experiences. During the 1960s, Sugimoto began to work in a new medium—printmaking. Using linoleum and woodblock, he turned many of

3. In 1952 Congress passed the Walter-McCarran Act which, among other things, gave immigrants from Japan the right to apply for naturalization. Sugimoto became a U.S. citizen in 1953.

his camp scenes into stark black-and-white images. At a time when most Japanese Americans did not openly discuss or acknowledge their incarceration, Sugimoto continued to re-envision this experience in his work. Although his paintings were often rejected because of their subject matter, he persisted, determined to present his experiences to the public.

Not simply a rehashing of the old themes, nor merely an attempt to reestablish his career, these camp paintings and prints demonstrate Sugimoto's ardent engagement with his work; strikingly different from his previous work, they are the skilled renditions of a mature artist, revealing the range of his reactions to a difficult experience.

Sugimoto further developed this historical and personal approach to his art in the 1960s and 1970s. He began to think about his life as an issei and decided to begin a series of works based on the Japanese immigrant experience in America. After researching the subject in books and visiting important sites, Sugimoto created the series that, along with his camp prints and paintings, would become his greatest legacy.

During this same period, the Japanese American community began to come to terms with their treatment during World War II. The sansei (third) generation, in particular, began asking their nisei parents about their experiences. The first pilgrimages to the sites of former camps took place in the late 1960s, and by the mid-1970s, the Japanese American community had begun to discuss the issue of redress for those incarcerated during the war.

As more people began to research the camp experience, the interest in Sugimoto and his body of work grew. Groups like the Japanese American Citizens League in New York and the Japanese Presbyterian Church organized exhibitions of Sugimoto's paintings in the 1970s. These public events no doubt encouraged dialogue on a subject that until then had been considered too difficult for discussion. As the movement for redress and reparations continued, Sugimoto was singled out as someone who could speak publicly about the World War II experience. In 1981 he testified before the U.S. Commission on Wartime Relocation and Internment of Civilians and showed several of his paintings. His art conveyed much of the emotion of the war, in ways that verbal

and written testimony could not. The hearings were the first time that Japanese Americans discussed their wartime experiences publicly, in detail. They were cathartic for the whole community and helped to rally support for a government apology and individual compensation to those who had been incarcerated. In 1988, President Ronald Reagan signed H.R. 442, the redress and reparations bill, which provided a formal apology from the U.S. government and a $20,000 payment to every living person who had been incarcerated during the war. For Sugimoto and other Japanese Americans, the significance of the redress bill rested in the government's recognition of its mistake.

At exhibitions sponsored by the California Historical Society and the Smithsonian Institution's National Museum of American History, Sugimoto's work has gained greater exposure to the American public. These exhibitions about the incarceration of Japanese Americans, in which Sugimoto's work is a powerful element, have helped to bring about greater understanding of this historical period.

By the early 1980s, Sugimoto found that the Japanese were now ready to face the past, including the painful war years, and had become fascinated with the experiences of Japanese Americans during World War II. In an effort to ensure their awareness of the Japanese American wartime experience, he donated numerous works to the city library and the Museum of Modern Art in Wakayama, Japan, his native city.

Although Sugimoto called a number of places home throughout his lifetime—Japan, Hanford, the San Francisco Bay Area, France, and Arkansas—he spent the most time in New York City, where he lived out his final days. As an elderly man he naturally weakened physically, and grew despondent when his wife, Susie, died in 1987. Nevertheless, he had a determined spirit and continued to paint, buoyed by the support and care of daughter Madeleine. In his late eighties, Sugimoto battled cancer, and still, whenever he was able, got out of bed and went to his studio at the north end of the West 146th Street apartment. There he painted at his easel, the way he had created his art throughout his life. In 1990 Sugimoto passed away in New York City.

In his long life, he had traveled widely—around the planet and on his own interior journey; infatuated with the world of art and artists as a young man, captivated by the beauty of his surroundings, Sugimoto was forced in middle age, by circumstances and by his own artistic drive, to come to terms with a much more complex world. As it turned out, his passion for Western-style painting gave him the wherewithal to tell the stories of his own Japanese American community.

Sugimoto's willingness to share his own story has inspired other Japanese Americans to do the same. For Japanese Americans, his work encapsulates their own history, validating their experiences and igniting new dialogue about what it means to be an American of Japanese ancestry. For others, Sugimoto's art reveals the fundamental American experience of an immigrant who, because he was not readily accepted, learned not to take for granted the privileges of citizenship. It was in this roundabout way that Sugimoto came to embrace the very ideals of being an American and to paint, uniquely and authentically, an American experience.

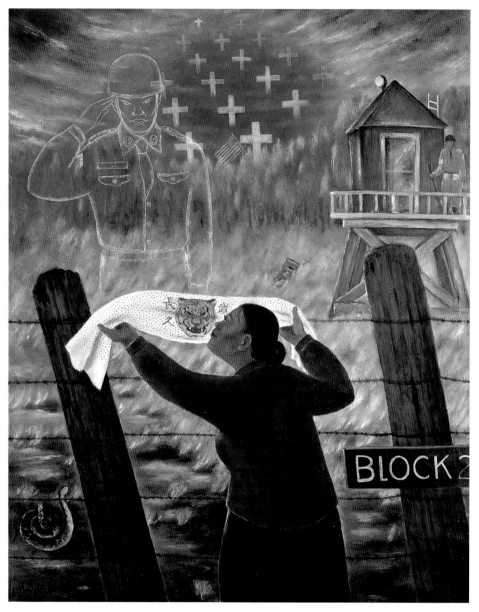

In the years following World War II, Sugimoto revisited the subject of the concentration camps many times in his art. Often repainting compositions he created during the war, he translated many works onto larger canvases and inserted new details.

Senninbari, 1982
Oil on canvas, 64¹/₂ x 51¹/₂ inches
(92.97.140)

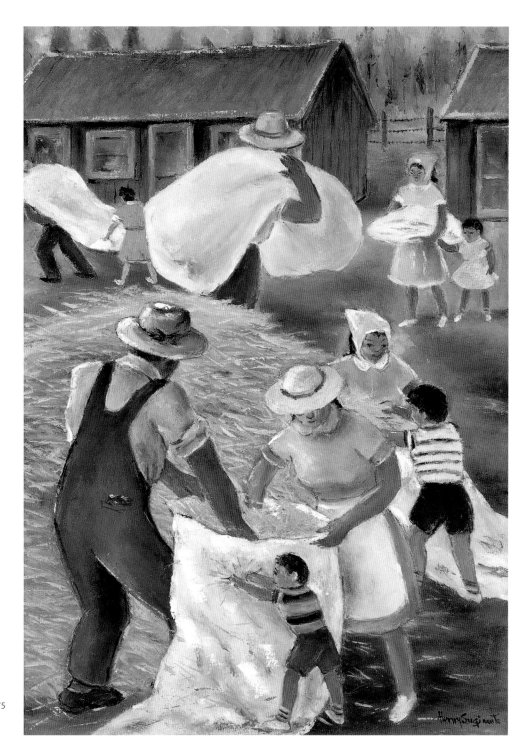

Making Our Mattress, ca. 1975
Oil on canvas, 32 x 23 inches
(92.97.2)

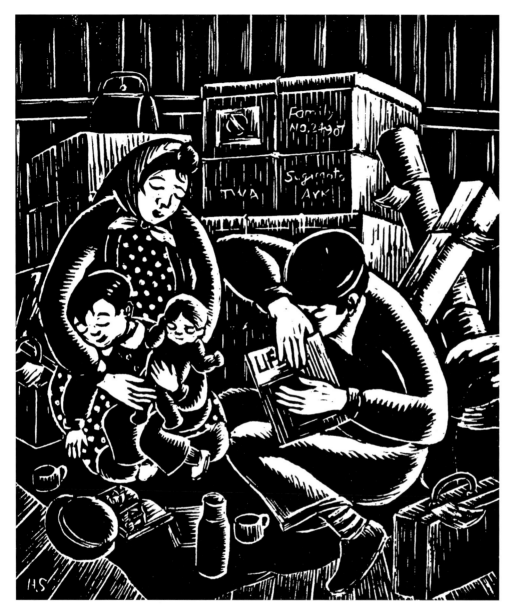

Arrival at Jerome, ca. 1965
Woodblock print, 8 ¼ x 6 ¾ inches
(100.2000.46V)

Sugimoto's woodcut prints of camp images are a powerful example of his ongoing development of the same subject matter in fresh new ways. While he translated many of his paintings straightforwardly into prints, he also created completely new compositions that take advantage of the more graphic nature of printmaking.

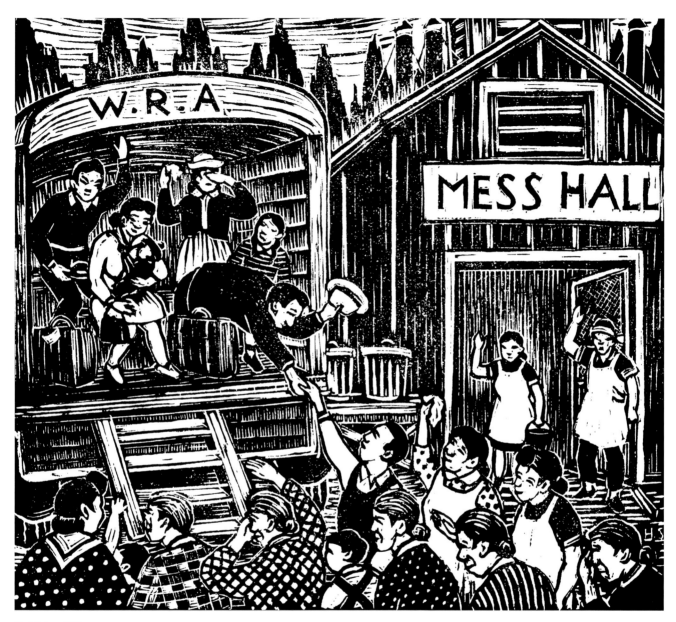

Untitled, ca. 1965
Woodblock print, 6 ¾ x 8 ¼ inches
(100.2000.47R)

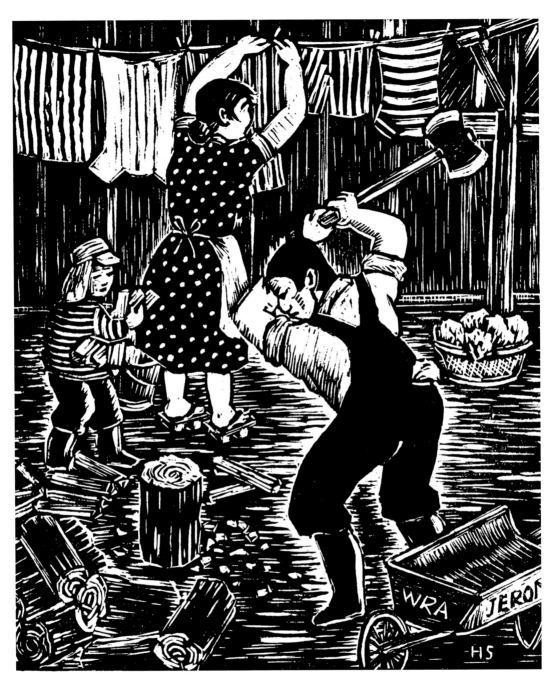

Untitled, ca. 1965
Woodblock print, 8¼ x 6¾ inches
(100.2000.46S)

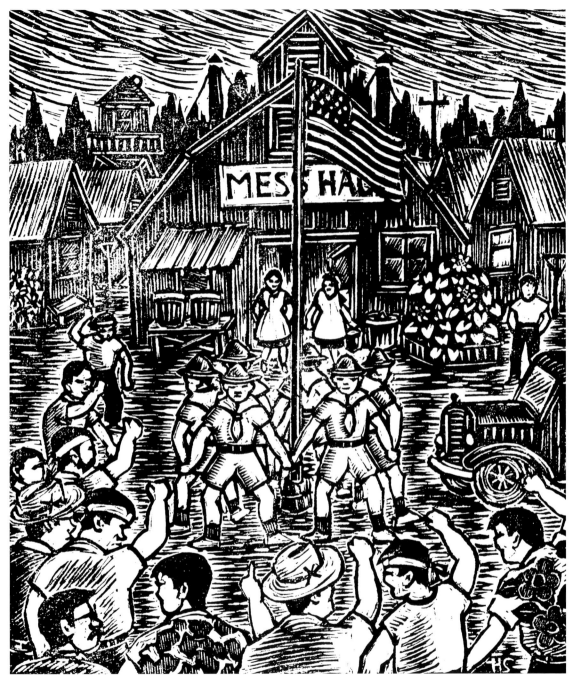

113

Untitled, ca. 1965
Woodblock print, 8¼ x 6¾ inches
(100.2000.46Z)

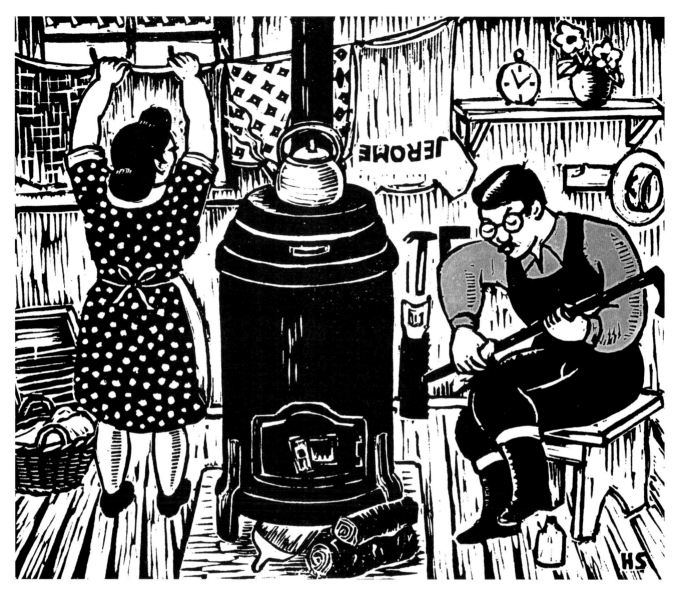

Saturday Afternoon, ca. 1965
Woodblock print, 6¾ x 8¼ inches
(100.2000.46D)

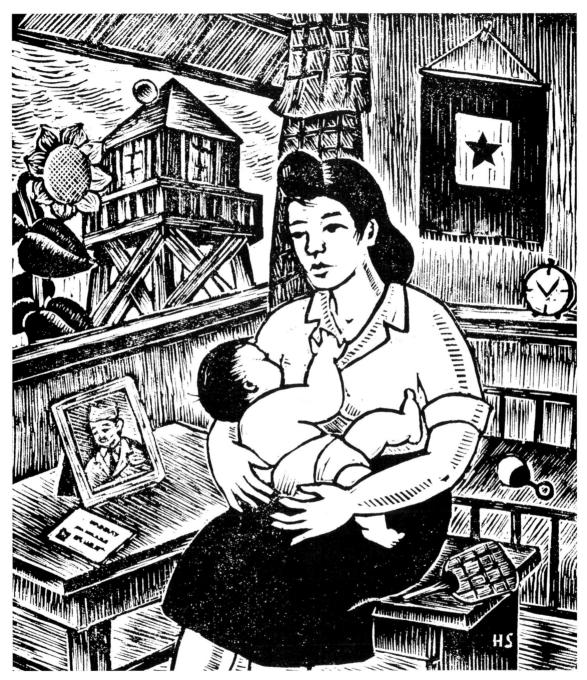

Thoughts of Him, ca. 1965
Woodblock print, 8¼ x 6¾ inches
(100.2000.46DD)

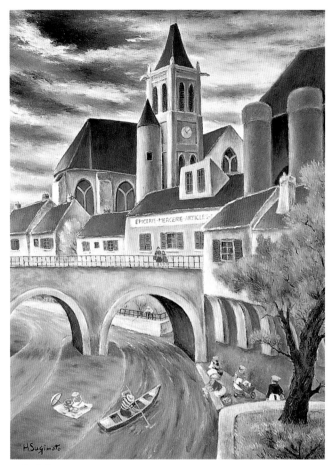

Cathedral Morret, 1965
Oil on canvas, 38 x 51 inches
Collection of Madeleine Sugimoto
(NY44)

Sketch, 1965
Pencil and charcoal on paper
(100.200.14)

Birth of America, 1976
Oil on canvas, 51¼ x 63¾ inches
Collection of Madeleine Sugimoto
(NY2)

Sketch, 1965
Pencil and charcoal on paper
(100.200.14)

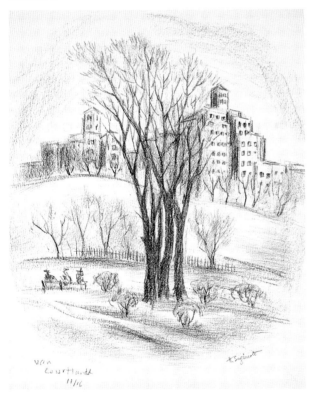

New York Wind, 1964
Oil on canvas, 24¼ x 29½ inches
(NY 87, FAE 38)

My Studio, ca. 1965
Woodblock print
(100.2000.47C)

The Little Church in New York City, ca. 1965
Woodblock print
(100.2000.47F)

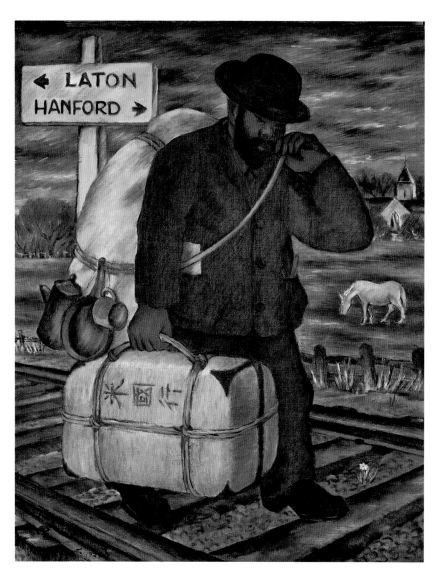

To Find a Job, ca. 1950
Oil on canvas
31²/₃ x 25¹/₂ inches
(92.97.107)

Sugimoto's sustained focus on the past led him to consider the entire history of Japanese in the United States. His research led him to a wealth of material well suited for his documentary-style work: the typical experiences of Japanese men who immigrated to the United States around the turn of the century, working as laborers on the railroads, in coal mines, and on farms. Interestingly, these paintings reflect little of Sugimoto's own personal experiences, as he took a path quite different from that of most of his issei counterparts. These powerful paintings are the only portrayals of issei life known to exist in an artistic form and on this scale.

Coal Miners, ca. 1960
Oil on canvas, 64 x 51½ inches
(92.97.111)

122

Picking Grapes, 1970
Oil on canvas, 51¹/₂ x 64 inches
(92.97.133)

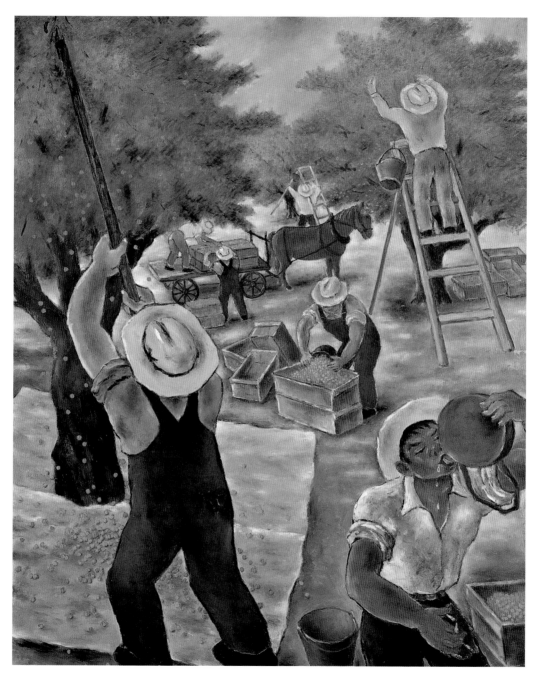

Working on a Farm, 1970
Oil on canvas, 64 x 51½ inches
(92.97.110)

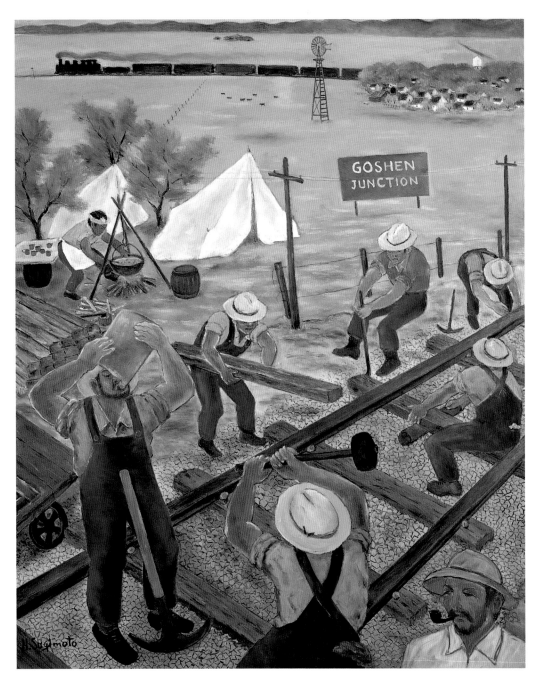

124

Railroad Work, 1970
Oil on canvas, 64 x 51½ inches
(92.97.109)

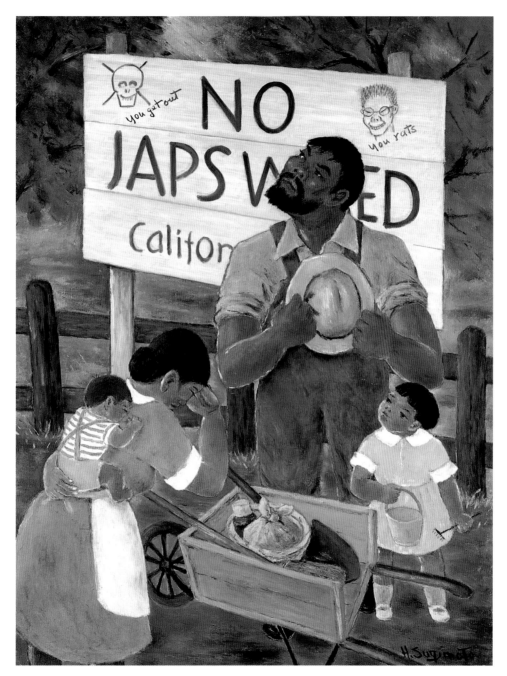

Untitled, 1965
Oil on canvas, 51 x 38 inches
(92.97.122)

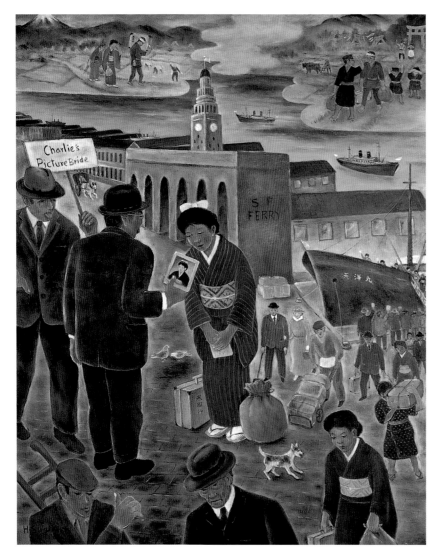

Picture Bride, 1965
Oil on canvas, 64 x 51½ inches
(92.97.108)

Since most issei were single men when they immigrated, it was not uncommon to find a wife through correspondence and the exchange of photographs. Many issei women thus came to the United States as "picture brides." In 1924 the United States passed a law barring further immigration of Japanese women. Since an earlier law had already halted the mass immigration of Japanese men, it was evident that the purpose of the 1924 act was to discourage the establishment of families and communities of Japanese Americans. Sugimoto's paintings use iconic figures like Uncle Sam to refer to these historical and political events.

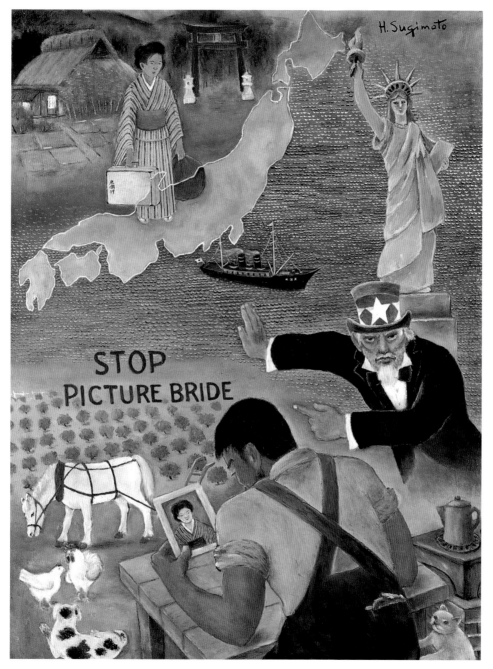

Stop Picture Bride, 1965
Oil on canvas, 51 x 38 inches
(92.97.121)

Leaving Your Mark
on this Earth

by HENRY SUGIMOTO

Henry Sugimoto, according to his own statements and the accounts of his family, felt most comfortable expressing himself in paint, not words. It is curious, then, that at the age of 78 he decided to write his memoirs. Spanning the years from childhood to his life in New York, Sugimoto's writing relates his motivations, emotions, and beliefs with regard to art, family, and the world. While the motivation for his written reflections is unknown, they are a tremendous help in understanding him as a person and artist. Together, his writing and the body of art he created in his lifetime provide an in-depth portrait of a man who lived life determined to follow his dreams. The following chapter from Sugimoto's life story reveals his everlasting belief in the power of art to transform and inspire, as well as his dedication to making a difference in the world.

EVERY MORNING WHEN I wake up and before I eat breakfast, I go down to a newspaper stand nearby and buy the *New York Times*. Then I go for a walk along the Hudson River on Riverside Drive, to a place where I can get a good view of the New Jersey hills—a walk of about ten blocks—and I say my morning prayer there and then return home. As long as the weather isn't bad, I do this every morning.

It has been more than thirty years since I left camp and moved to New York City.

It has been snowing heavily since early this morning, and when I got to the Drive [Riverside], there were already two inches of snow on the ground. I thought I should get to my prayer spot before the snow got too deep. The ground was already covered in snow, and while I didn't see anyone else walking, the footprints of people who had been walking earlier had left a clear mark on the snow-covered sidewalk. But even these footprints were disappearing quickly as the snow continued to fall. I was reminded of something my wife's mother had once said: "You must live your life so that when you die, you will leave behind a worthwhile mark." In other words, when you die, you must leave your mark on this earth.

Right now, as far as the eye can see along Riverside Drive, the benches on both sides and the trees are all covered in a white blanket of snow, and it looks like a completely different world. When I saw that the only thing that stood out clearly were my own fresh footprints, I felt like this Riverside Drive was my own snowy path to walk on. And I was reminded of the words of my wife's deceased mother and it made me think. It has been more than seventy years since I was given life here on this earth, but I have to wonder if I will have something to show for my life. Just as my footprints are leaving a distinct mark on the snowy path, will my life leave a fruitful mark on this earth? So thinking, I went to my prayer spot and prayed: "God, please guide me and bless me so that my work will leave behind a beautiful mark, just as my footprints left a beautiful mark on the sidewalk in the snow. And please allow me to continue to devote myself to art. Please help me continue to make paintings that will contribute to the world and to the international art community. And please use my paintings so that, even in small ways, you will be glorified." With my head lowered, I prayed quietly and returned home.

As I walked home, I watched as my fresh footprints appeared on the path. The snow fell steadily with no sign of letting up. They were saying on television that there could be five inches of snow by the end of the day. I went home feeling sad that the footprints I had just left in the snow would be covered over

by the snow falling later on. As I thought of how—what with the changes in
the world and the passage of time—the mark you leave on this world can be
washed away without a trace, I was convinced that I could not let the mark that
I leave behind be such that it could eventually be washed away and disappear.

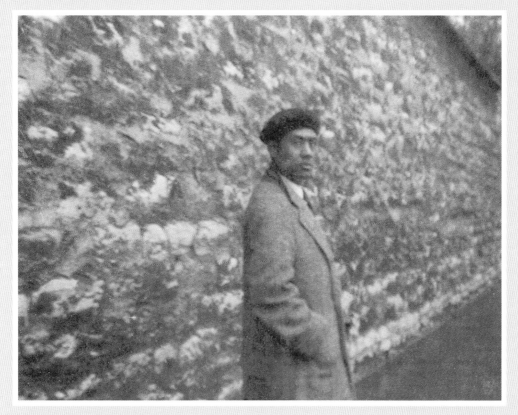

Henry Sugimoto in France, ca. 1930
(2000.381.15)

A Daughter's Remembrance

MADELEINE SUMILE SUGIMOTO

OFTEN PEOPLE HAVE remarked that I must know a great deal about art because my father was an artist. Candidly and ruefully, I have to admit that is not so. Our conversations were more mundane, those of a daughter and her parent.

After having been uprooted from our home in Hanford, California, and moved about from Fresno Assembly Center to two concentration camps in Arkansas, Jerome and Rohwer, we settled in New York City, a longtime hope my father was finally able to realize. Through all those years, home was where we were together as a family. In New York, my father enjoyed exploring the city. Our outings—walks, picnics, ferryboat rides, and community activities—are all happy memories. My father was an avid baseball fan, and so the joys and sorrows of games lost or won by his favorite Mets were an ongoing topic of conversation. My father came to my rescue as I prepared for my State Regents exam, struggling with the difficult subject of geometry. Patiently, he helped me work through weeks of solving those formidable problems.

There was always the studio, and there was always our home. Both occupied space in our apartment. The studio was where my father carried out his work before joining us at the end of the day for our time together as a family.

I can characterize my father's approach to work—discipline, effort, and commitment. For most of us who work outside the home, there is an externally imposed schedule that structures our workday. Being curious, I asked him about how he set about doing his work. To my amazement, he outlined the plan for each day of the week. As he only painted by daylight, on rainy days he would make frames or size canvases or work on his linoleum or woodcuts, remaining in the studio throughout the day except when my mother would call him for his lunch.

In the 1980s, a few friends were invited to view the large mural commissioned for the Wakayama city hall. Before those present, my father acknowledged that "Susie made it possible for me to paint." It impressed me how he valued my mother's sustaining devotion to him, that theirs was an enduring and understanding partnership.

The formality of my father's words and carriage, if an occasion so demanded, harkened back to his early upbringing in Japan; yet he could enjoy a hearty laugh, tell humorous stories or jokes, or get up to sing a song at a party. My father had assimilated cultural mores from his travels around the world and his years of study in France, so there was a delightful blend of East and West in his relationships.

There was a sense of enthusiasm and purpose to his work, which spanned most of the twentieth century. To see him, frail yet energized, standing before the easel with palette in hand, applying sure brush strokes to canvas, is a cherished image. My father, even in his last years, told me that to be able to paint "even for fifteen minutes makes me feel alive."

My father had both a strong and gentle nature. His personal resources were all that he felt and experienced in his life, and his abiding faith in God. I believe these animated his spirit and enabled his lifelong creativity.

And so—even from afar—he greets us all as we view his work.

Madeleine Sugimoto with her father and mother
in their New York apartment, ca. 1965.

Resource List

The Japanese American National Museum has the largest collection of art and writing by Henry Sugimoto, in addition to holdings of documents, personal papers, ephemera, and photographs related to the artist. These materials form the basis for this publication and the related exhibition.

Other institutions that have collected artwork by Henry Sugimoto include: California College of Arts and Crafts, Oakland, California; Fine Arts Museums of San Francisco, San Francisco, California; Hendrix College, Conway, Arkansas; Hiroshima Peace Memorial Museum, Hiroshima Prefecture, Japan; Kings Art Center, Hanford, California; Musée de Crècy, Crècy-en-brie, France; National Museum of Modern Art, Tokyo, Japan; Smithsonian National Museum of American History, Washington, D.C.; University of Arkansas, Fayetteville, Arkansas; Wakayama City Hall and Wakayama City Library, Wakayama Prefecture, Japan.

Secondary sources include:

Eaton, Allen E. *Beauty Behind Barbed Wire: The Arts of the Japanese in Our War Relocation Camps.* New York: Harper & Brothers Publishers, 1952.

Gesensway, Deborah and Mindy Roseman. *Beyond Words: Images from America's Concentration Camps.* Ithaca, NY: Cornell University Press, 1987.

Higa, Karin M. *The View From Within: Japanese American Art from the Internment Camps, 1942–1945.* Seattle: University of Washington Press, 1992.

Hughes, Edan Milton. *Artists in California: 1786—1940*. San Francisco: Hughes Publishing Company, 1989.

Inada, Lawson Fusao. *Only What We Could Carry: The Japanese American Internment Experience*. Berkeley, California: Heyday Books, 2000.

Kikumura, Akemi. *Issei Pioneers: Hawai'i and the Mainland, 1885 to 1924*. Los Angeles: Japanese American National Museum, 1992.

Kim, Hyung-chan, ed. *Distinguished Asian Americans: A Biographical Dictionary*. Westport, CN: Greenwood Press, 1999.

Kubo, Sadajiro, ed. *Hokubei Nihonjin no Shuyojo (The Internment Camps of Japanese North Americans)*. Tokyo: Sobunsha, 1982.

Niiya, Brian, ed. *Japanese American History: An A-to-Z Reference from 1868 to the Present*. New York: Facts on File, 1993.

Tokyo Metropolitan Teien Art Museum. *Japanese and Japanese American Painters in the United States: A Half-Century of Hope and Suffering, 1896—1945*. Tokyo: Nippon Television Network Corporation, 1995.

Acknowledgments

It has been a privilege to bring Henry Sugimoto's story to light. Many people assisted Karin Higa and me in the creation of this project, and without them it would not have been possible.

First, we must acknowledge Henry Sugimoto and his incredible artistic legacy. Before the Japanese American National Museum even opened to the public, he entrusted us with a substantial bequest. (All artwork and archival materials in this book are part of the museum's permanent collection and are a gift of Madeleine Sugimoto and Naomi Tagawa, unless otherwise noted.) We are indebted to Henry Sugimoto and his family for sharing his life's work with our institution. We especially thank his daughter, Madeleine, without whom this project would not have been possible.

Thanks to Naomi Tagawa for welcoming us into her home in Hanford, California, and sharing her family history. We appreciate the assistance of the entire Sugimoto family, in particular Dan and Anna Sugimoto and their sons Craig and Norman Sugimoto. Norman also deserves thanks for his role as photographer at the Japanese American National Museum.

Karin and I are grateful for the leadership of Irene Y. Hirano, executive director of the Japanese American National Museum, who worked alongside other staff to bring Henry Sugimoto's work to our institution in 1990. Others who made the donation possible include Sara Iwahashi, Brian Niiya, Dean Toji, and Akemi Kikumura-Yano. Thanks also to the museum's board of trustees, in particular Frank Ellsworth, Eileen Kurahashi, George Takei, and Gordon Yamate.

Under the capable leadership of Audrey Lee-Sung, the following dedicated people worked on this project: Snowden Becker, Nikki Chang, John Esaki, Clement Hanami, VV Hsu, Cheryl Ikemiya, Karen Ishizuka, Flora Ito, Sharon Kamegai-Cocita, Tami Kaneshiro, John Katagi, Heidi Kato, Chris Komai, Carol Komatsuka, Maria Kwong, Theresa Manalo, Toshiko McCallum, Yoshi Miki, Grace Murakami, Bob Nakamura, Rick Noguchi, Azusa Oda, Leticia Rodriguez, Christen Sasaki, Claudia Sobral, Ronald Stroud, Cameron Trowbridge, Mitsue Watanabe, Juliet Wong, and Lucia Yang. Additional support was provided by Nancy Araki, Luke Gilliland-Swetland, Cayleen Nakamura, Ed Prohaska, and Susan Redfield. A hearty thank-you to museum volunteers Amy Kato, Eddy Kurushima, Richard and Masako Murakami, and Bob and Rumi Uragami. We are grateful to our colleagues in the curatorial and exhibitions department, Eiichiro Azuma, James Hirabayashi, Darcie Iki, Sojin Kim, Kaleigh Komatsu, Jennifer Mikami, and Audrey Muromoto, for their encouragement and expert advice. Thanks to Lloyd Inui for his insights and sound judgment. Karin and I thank Kirstin Ellsworth for her incredible research skills. Emily Anderson played a crucial role on the project, translating Sugimoto's papers with intelligence and sensitivity. Her attention to every detail of the project was essential to its realization.

We thank Secretary Lawrence M. Small of the Smithsonian Institution for his contribution to this publication and especially John Yahner for his assistance.

We are grateful for the support we received from AT&T, the Henry Sugimoto Foundation, Winthrop Rockefeller Foundation, The James Irvine Foundation, the Los Angeles County Arts Commission, and the National Endowment for the Arts. Karin Higa and I thank the following individuals for their support and guidance: Russell Ferguson, Kimi Kodani Hill, Mark Johnson, Donald McCallum, Gary Moriwaki, Robert Marcellus and his staff at the Kings Art Center, Suzanne Sato, and Cecile Whiting.

Karin Higa would also like to thank Kippy Stroud and her staff at Acadia Summer Arts Program, and Tim Burgard of the Fine Arts Museums of San Francisco, for providing opportunities to discuss Sugimoto's work.

This publication came about through a wonderful partnership with Heyday Books. We are indebted to Malcolm Margolin and Patricia Wakida for helping share Henry Sugimoto's story. Thanks to Jeannine Gendar for her discerning editorial eye and the entire staff of Heyday Books. It was a joy to work with David Bullen, who created the elegant design of this book.

My deepest appreciation goes to my family: Rodney and Rachel Kim, Sung-do and Millicent Kim, Tamotsu and Masako Kimura, Cheryl and Guy Pacarro, David Kim, and Jennifer, Paul, David-Paul, and Claire Mikami. Finally, my gratitude to Ron Stroud for his unwavering support. *Kristine Kim*

Kristine Kim is associate curator at the Japanese American National Museum, where she previously organized the exhibition *A Process of Reflection: Paintings by Hisako Hibi*. She received a B.A. from Mills College in 1994 and is currently completing graduate work in the department of art history at the University of California, Los Angeles. Her research focuses on twentieth-century art and Asian American artists.

This book is published as a companion to the exhibition *Henry Sugimoto: Painting an American Experience,* which was organized by the Japanese American National Museum in Los Angeles.

The mission of the Japanese American National Museum is to promote understanding and appreciation of America's ethnic and cultural diversity by preserving, interpreting, and sharing the experiences of Japanese Americans. By building a comprehensive collection of objects, photographs, works of art, home movies, books, and manuscripts, and presenting a multifaceted program of exhibitions, educational programs, media projects, and publications, the National Museum tells the story of Japanese Americans to audiences nationally and internationally.

Japanese American National Museum
369 E. First Street, Los Angeles, California 90012
213.625.0414
Web site: *http://www.janm.org*

JAPANESE AMERICAN
NATIONAL MUSEUM